DIDSBURY
THROUGH TIME
Peter Topping &
Andrew Simpson

Andrew

AMBERLEY PUBLISHING

About the Authors

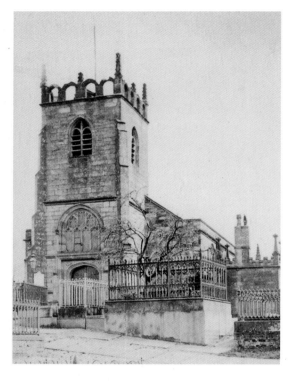

Peter Topping and Andrew Simpson have been working together for a number of years developing projects linked to the history of South Manchester. It is, as Peter said, a collaboration where he paints the pictures and Andrew tells the stories. Their work has appeared in venues across South Manchester, including an 80-metre mural, which was commissioned by a large building company and opened by Lord Bradley of Withington in 2012. Both also work independently.

Peter's work is much admired and he regularly exhibits his work, showcasing it on his website at www.paintingsfrompictures. co.uk/paintings.

Andrew recently published a book on the history of Chorlton-cum-Hardy in 2012, writes articles on local history and produces a popular history blog at www.chorltonhistory.blogspot.co.uk.

First published 2013

Amberley Publishing
The Hill, Stroud, Gloucestershire, GL5 4EP
www.amberley-books.com

ISBN 978 1 4456 1726 8 (print)
ISBN 978 1 4456 1738 1 (ebook)

British Library Cataloguing in Publication Data.
A catalogue record for this book is available from the British Library.

Typesetting by Amberley Publishing.
Printed in Great Britain.

Introduction

There has been a settlement at Didsbury since before William's men compiled the Domesday Book. Back then, and for centuries, it was a small rural community, which has subsequently grown into a large, vibrant, cosmopolitan place.

It nestles beside the River Mersey, which has been both a gift to Didsbury and at times a threat. On the upside, the Mersey has provided a natural barrier in more unsettled times, driven the mills along its banks and provided water. But it remains a powerful and, at times, dangerous force that can breach the defences and flood large parts of the neighbouring land. Not that this stopped the wealthy from building fine houses beyond the floodplain, and some of these that date from the eighteenth and early nineteenth centuries still survive. They are no longer the private residences of the rich but have been converted into a range of uses, from offices to educational establishments and charitable trusts.

From the mid-nineteenth century, Didsbury increasingly attracted the middling sort of people who were solicitors, bankers and a whole raft of other professionals. Their tall, semi-detached villas with grand sounding names like Woodlands and the Headstones spread across the western edge of the township.

Closer to the old centre and tucked away down the narrow side streets were the homes of the not so well-off, while behind banks of trees and set in their own large estates were the properties of the very rich.

The coming of the railway in 1880, followed by the extension of the Corporation's electric tram network at the beginning of the next century, made Didsbury an even more attractive place for those who worked in the city but wanted to live close to the countryside. It was now possible to make the journey from Didsbury to the centre of Manchester in just over twenty minutes.

Added to this were improvements in the provision of water, sewage, gas and electric supplies, all of which were essential to support a rapidly growing population. And it was the promise of cheaper rates, transport fares and cheaper gas and water charges, along with a modern library that swung the vote for incorporation with Manchester in 1904.

During the next 100 years, Didsbury pretty much evolved into what we see today. The last fields have all but gone, replaced with rows of semi-detached, modest housing, a new road link into the city and a teacher training college. Along the way, we lost our two cinemas only to gain a vast entertainment complex at Parrs Woods and have experienced the growth of the café culture on the Wilmslow corridor.

Now the teacher training college has also gone, as have some of the other old landmarks, but Didsbury continues to embrace change and so, while we lost a railway, we have gained a tram and there is still much of that heritage still to see and enjoy.

The book has been designed to take the reader across Didsbury from the east through the centre and out to the west. We have divided Didsbury into three sections starting in Parrs Wood in East Didsbury and then beyond the old village green and up to the junction of Barlow Moor Road, Wilmslow Road and School Lane, which forms a central part of the old township, and then along Barlow Moor Road to Christ Church in the west.

There are two additional sections, one featuring transport and the other a selection of postcards, from which many of the images of the book were drawn.

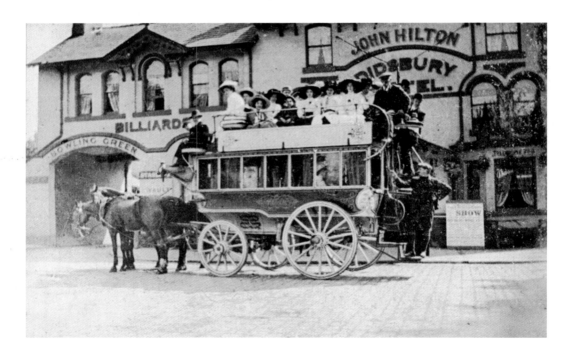

CHAPTER 1

Didsbury East

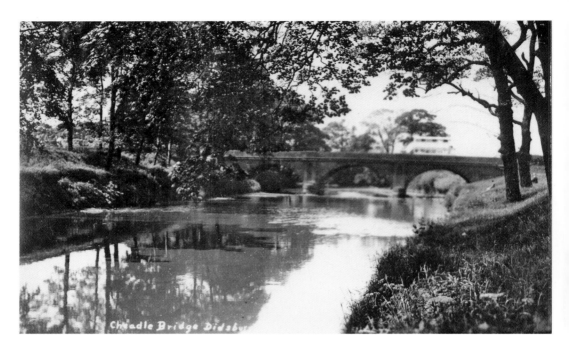

Cheadle Bridge Didsbury

Built in 1861 and for Seventy Years the Only Bridge Joining Didsbury to Cheadle

The view looking west towards Cheadle Bridge has not changed much in the ninety or so years that separate these two pictures. Just as then, people sit on the banks and watch the river glide by, while to the north and south there is still some open land. But beyond the bridge, there is The Kingsway, which was still just a drawing on the planner's maps in 1929 when our card was sent. With the coming of The Kingsway, there followed the sprawl of housing up to Parrs Wood Road.

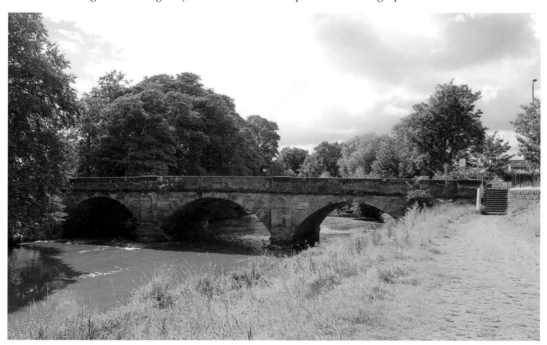

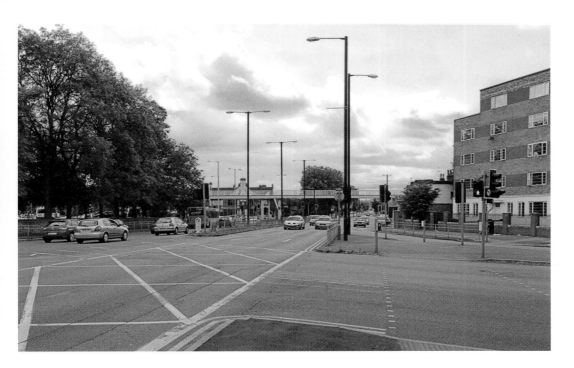

On The Kingsway

I doubt, even on the quietest Sunday or bank holiday, it would be possible to reproduce this traffic-free scene of The Kingsway by the Gateway Hotel. The Kingsway was extended beyond this point by 1934, and those solid, suburban houses followed soon after. Back then, it was still possible to advertise such homes as on the edge of 'green tranquility', just a short train ride from the city, with attractive grounds of Parrs Wood House just behind the bus to the left of our picture.

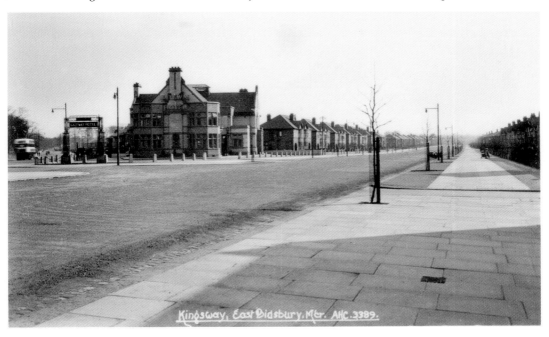

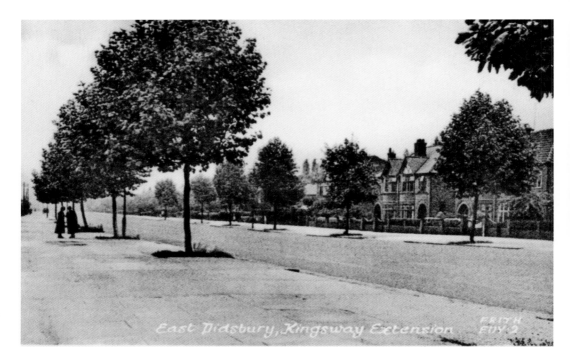

East Didsbury, Kingsway Extension

The Only Difference Now is the Endless Stream of Traffic

The caption on the postcards says East Didsbury, Kingsway Extension. Now there is no missing The Kingsway, which was was built in stages as a main route out of the city towards Cheadle. The first stretch from Levenshulme to Parrs Wood was built between 1928 and 1930, and by the mid-1930s it had reached Gawsworth Avenue. Our picture is just a little back of that point, roughly just south of the footbridge. I am not sure of the date, but the postcard comes from a collection that was being sold in the early 1950s.

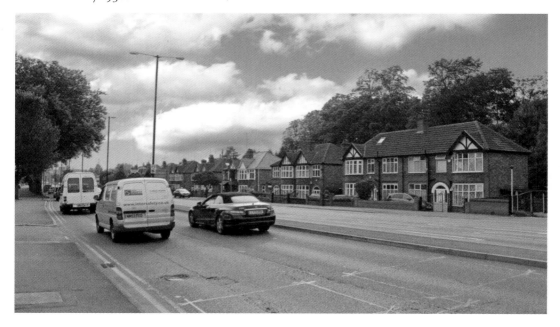

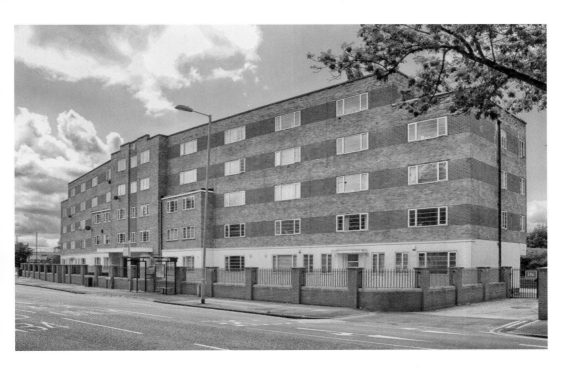

A Little of the 1930s at the End of Wilmslow Road

Parrs Wood Court still dominates the junction of Wilmslow Road and Kingsway as it has done since 1939. It might all have been a little different if, during the December of 1940, the four fire bombs that landed just a little to the north had hit the block, or for that matter, the powerful high-explosive bomb that landed almost directly opposite in the grounds of Parrs Wood House. It may well be that some of the residents had taken cover in the air-raid shelter that stood nearby.

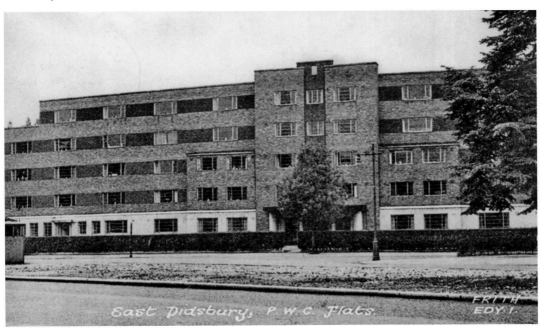

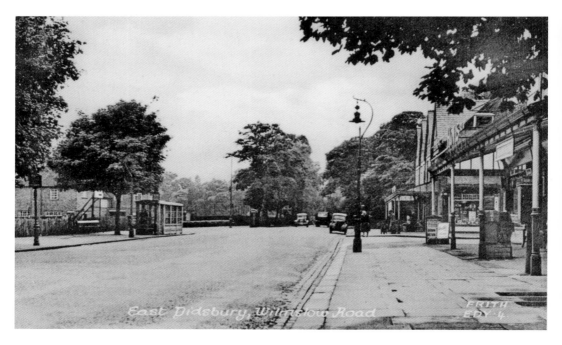

By Parrs Wood Arcade

It is a little busier today than it was in 1950, but this stretch of Wilmslow Road is pretty much still the same. Sadly, the cast-iron and glass canopy of some of the shops has gone, which always gave the parade a bit of style and kept you dry in the rain.

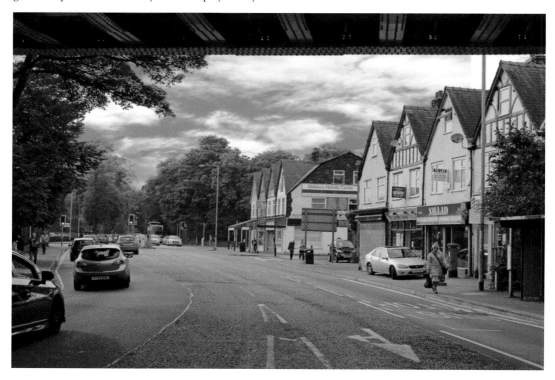

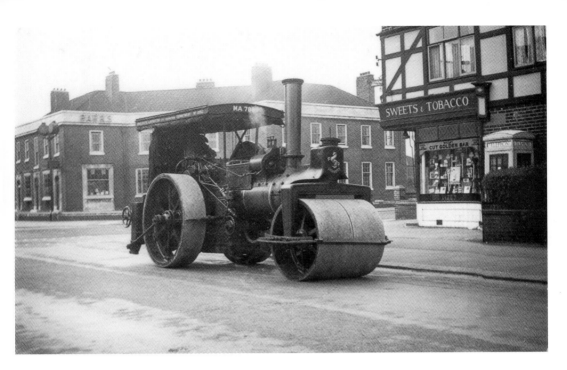

Every Collection Should Have a Steamroller

This is Manchester Corporation City Engineers Department steamroller No. 0302, passing the Parrs Wood Hotel in 1948, for all of you who love a steamroller. I am reliably informed that this was the sweet shop you visited first before heading off to the Capitol Cinema on the next corner. Sadly, both have gone but the pub remains.

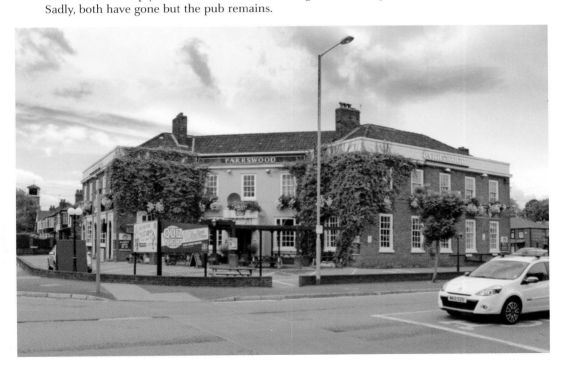

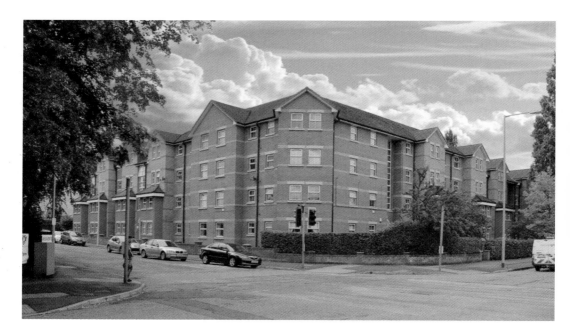

A Home to a Cinema, a Television Studio and a Theatre, Before Being Replaced by Flats
The Capitol Cinema opened for business on the corner of Parrs Wood Road and School Lane in May 1931 only to suffer a major fire just eleven months later. It reopened in August 1933 and remained a cinema until 1956 when it became a television studio, and was later converted into a theatre for Manchester Polytechnic. In 1999, it was demolished and the present building was constructed.

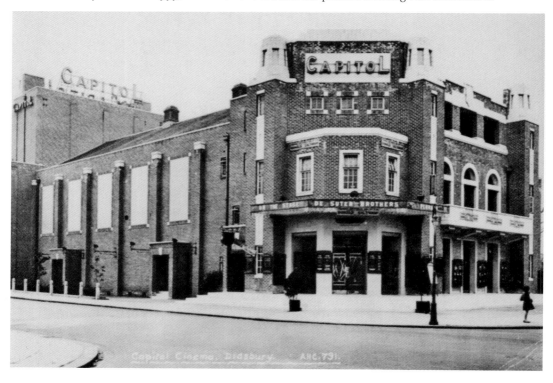

Decent Homes for all of Didsbury's Residents
The expansion of social housing programmes by the Corporation saw the development of estates along Parrs Wood Road from the 1920s onwards.

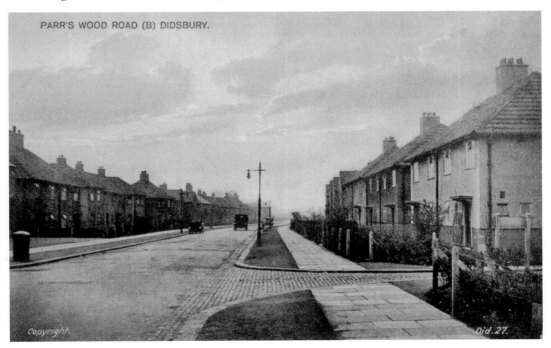

PARR'S WOOD ROAD (B) DIDSBURY.

Copyright.

Did. 27.

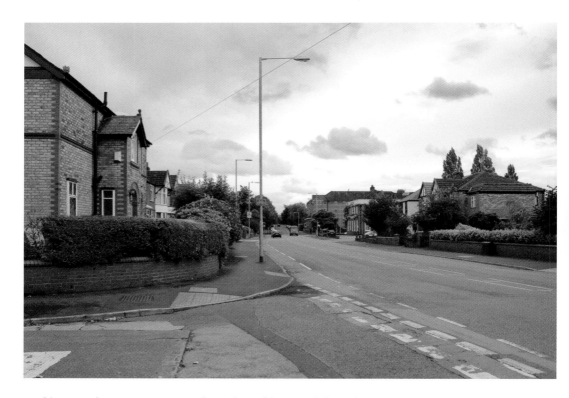

Looking South Down Parrs Wood Road; Nothing Much has Changed
In the distance on our right is the Parrs Wood Hotel and, beyond that, what had once been the Capital Cinema, which in 1956 became a television studio, before finally being demolished in 1999 to be replaced by a block of flats.

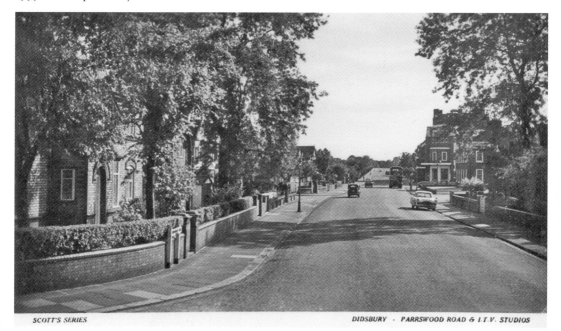

SCOTT'S SERIES DIDSBURY · PARRSWOOD ROAD & I.T.V. STUDIOS

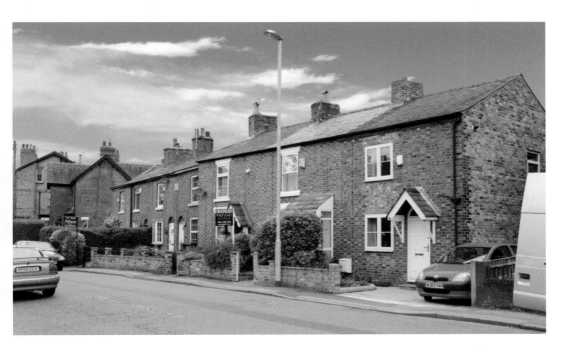

Handlooms and Weavers in Fog Lane Cottage

This is Fog Lane, and we are just west of Burnage railway station on the north side of the road sometime in the first decade of the twentieth century. One source refers to them as the 'Cotton Shops', which reminds us that Didsbury, like a lot of South Manchester, was once home to handloom weavers. By the time the picture was taken, they were home to a mixed group, including a day gardener, a labourer in the municipal cemetery, a servant and the son of a local farmer.

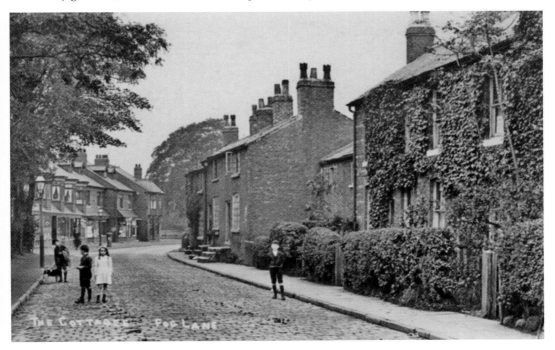

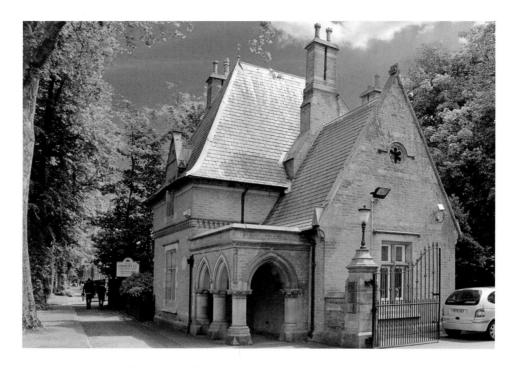

Don't Forget to Read the Blue Plaque on the Wall

Most of the people who pass the Lodge of the Towers in Wilmslow Road will not even give it a second glance, which is a shame because, in its own way, it is as fascinating as the main building. The entrance, with its arched passageway, the delicate windows and the tall roof and chimneys all demonstrate attention to detail and are an indication of what is to come along the drive in the estate.

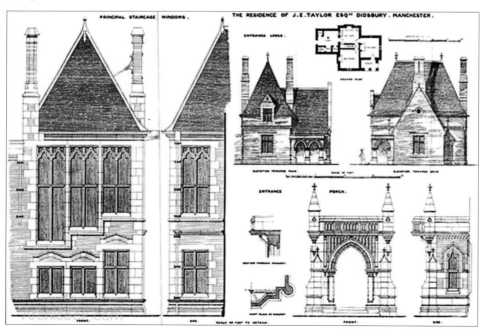

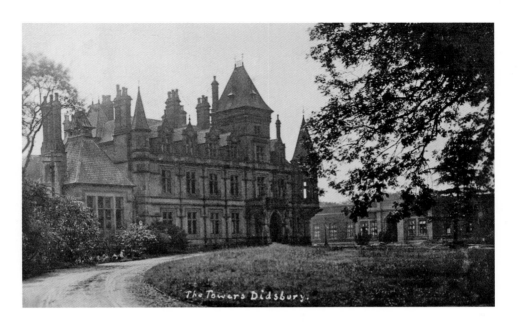

The Towers Didsbury.

The Manchester Ship Canal Started Here

The Towers was built between 1868 and 1872 by John Taylor, who founded the *Manchester Guardian* in 1821. Here, in 1882, the decision was taken by a group of businessmen to build the Manchester Ship Canal and, in 1920, it was bought by the British Cotton Industry Research Association and renamed the Shirley Institute after the daughter of one the main contributors to the cost of buying it. All of this fits perfectly with the message on the back written by Jean in 1921, proudly announcing that 'this is a view of the new Institute showing the new Lab where our Joe will shortly be working in the house'.

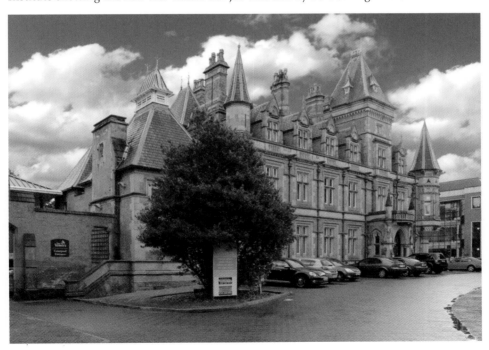

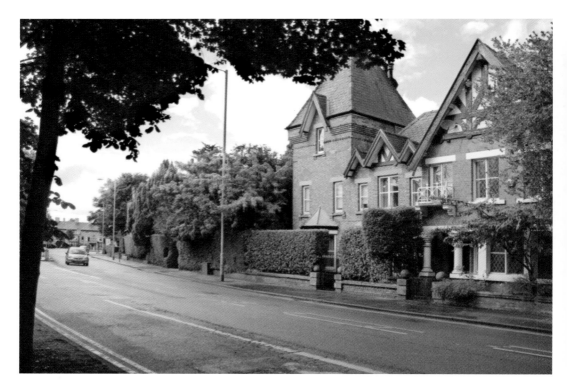

Little has Changed in Eighty-Nine Years

This is another of those Didsbury scenes that seem to have hardly changed despite the passage of eighty-nine years.

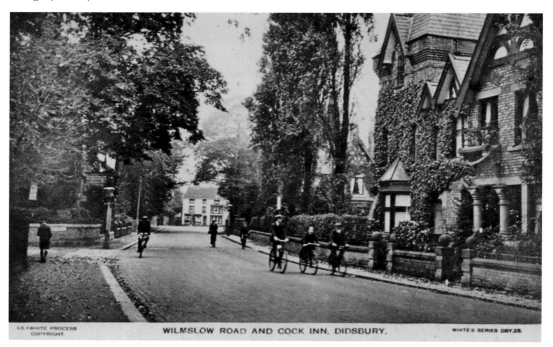

WILMSLOW ROAD AND COCK INN, DIDSBURY.

CHAPTER 2

Didsbury Centre

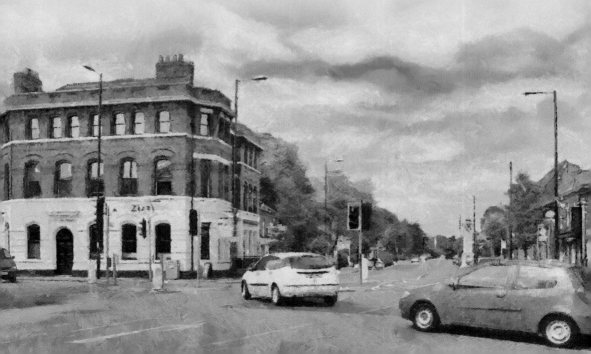

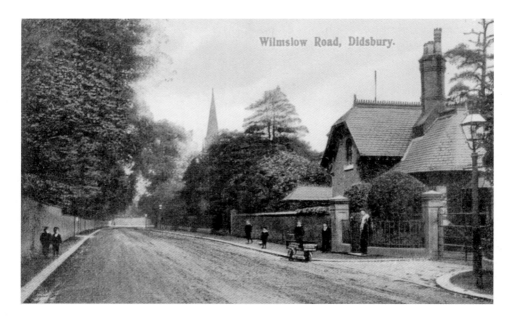

Wilmslow Road, Didsbury.

The Lodge at the Entrance to the University Grounds

This is another one of those scenes that, on the surface, appears to have changed very little. If you stand at this point and look north along Wilmslow Road, much appears the same. The lodge of the old Methodist College is still there, and the church of St Paul's pokes out above the trees. However, in the space of the century that separates the two, the horse has given way to the car, St Paul's is no longer a place of worship, and the site of the colleges has variously been a hospital and a teacher training college, and it will change again now that the Manchester Metropolitan University has moved to Birley Fields.

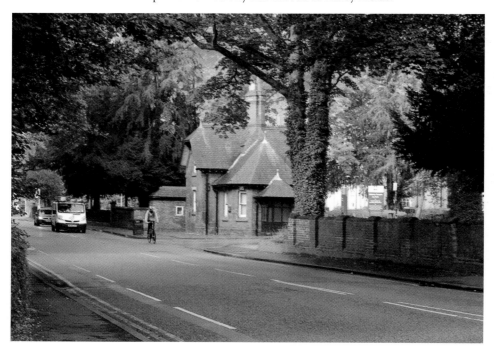

A Five-Roomed Cottage for a Jobbing or Domestic Gardener

We are on Wilmslow Road on a sunny afternoon looking east. Just behind us on the right is Millgate Lane, while ahead is Kingston Road. On our left, behind the two trees and the tall wall, is the home of Ernest and Edith Pritchard. He variously describes himself as a jobbing or domestic gardener, and their modest five-roomed cottage nestles beside the grander home of Elizabeth and Margaret Moyle, who describe themselves as restaurateurs.

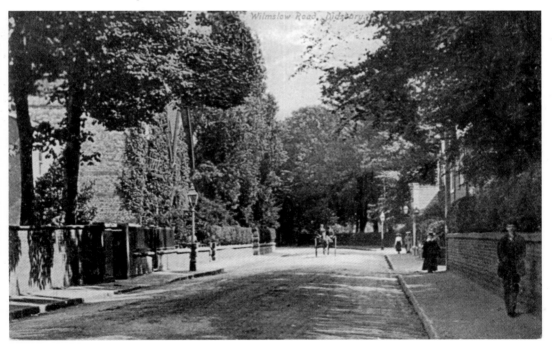

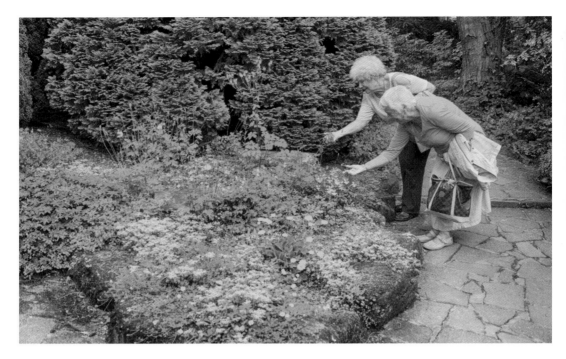

Fletcher Moss Gardens – a Gift to the People of Didsbury

Fletcher Moss Gardens have been giving delight to people for generations. They were originally laid out by Robert Wood Williamson, who sold them and his house, called The Croft, to Fletcher Moss, who in turn bequeathed them to Manchester Corporation in 1919. The gardens stretch south to the River Mersey and west to Stenner Woods.

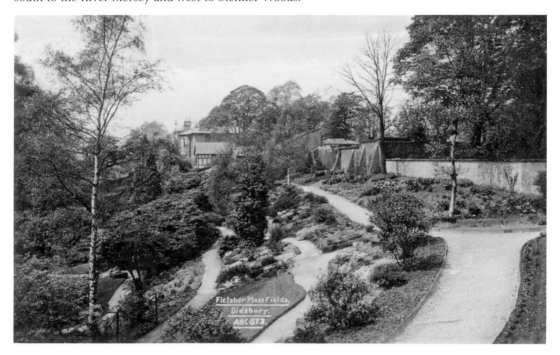

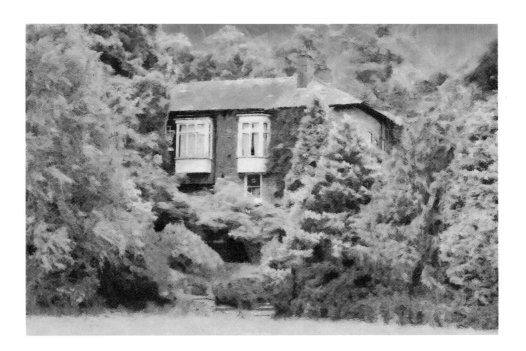

What Happened to the Top Storey of The Croft?

Now here is a mystery. Look closely at the two pictures of The Croft, which was formerly Willow Bank and is in the Fletcher Moss Gardens. Sometime between the two being taken, the top storey was taken away. Various suggestions have been put forward and the one favoured by the current gardeners was that dry rot had been found in the roof and upper floor and drastic action is needed. It was once the home of Mrs Emily Williamson, who helped establish the Royal Society for the Protection of Birds in 1889. The Williamsons moved and sold the property to Fletcher Moss, who gave the property and gardens to Manchester Corporation.

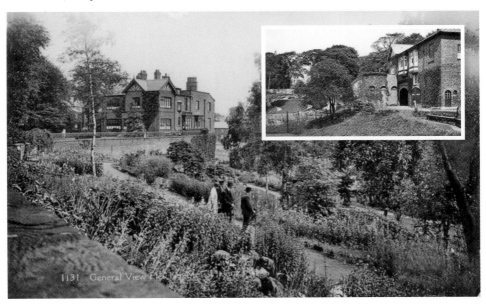

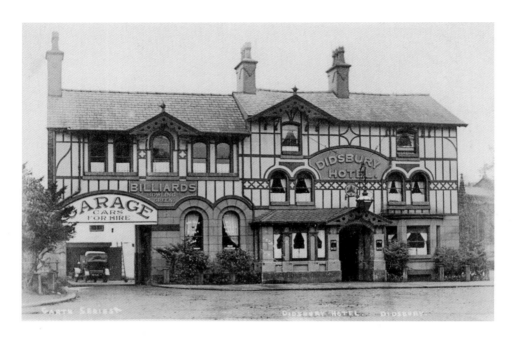

Now Known as Just The Didsbury it Still has its Distinctive Entrance

The Didsbury Hotel was built around 1855, and incorporated an older pub on the same site called the Church Inn, which early in the nineteenth century was known as the Ring of Bells. Originally, the arched entrance with its garage sign advertised the bowling green, which was behind the pub and to the left.

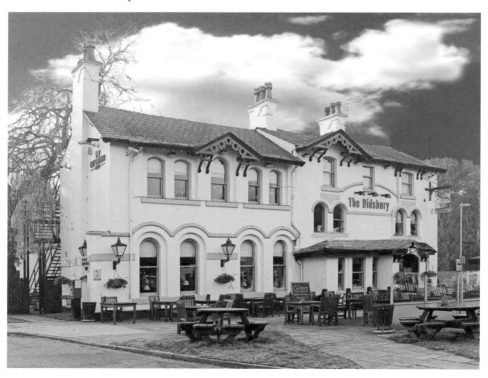

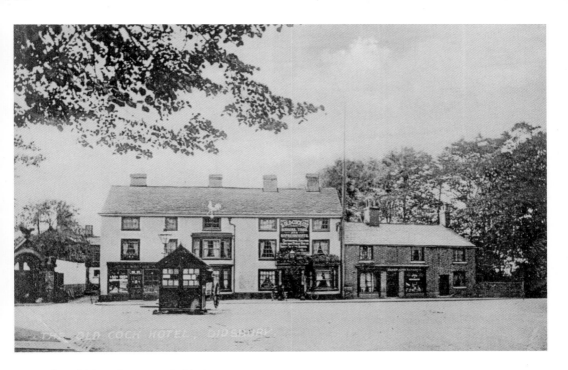

The Hidden Clues to a Pub's Past

The present Old Cock occupies a site that has been home to an inn since 1595, but the present building dates from the late eighteenth century and, in the ensuing 200 years, has lost some of its fine porch by the front door, along with the shop on the left. By the 1930s, the shop has been reduced in size to accommodate an entrance for cars to the car park behind. Later still, this and the shop went as the pub was extended. Equally interesting is the building to the right, which has been an antique shop, a café and a restaurant for most of the twentieth century and into the present.

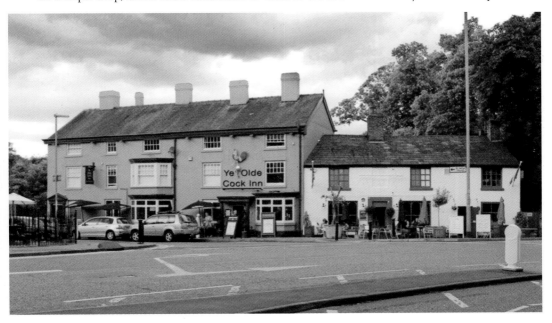

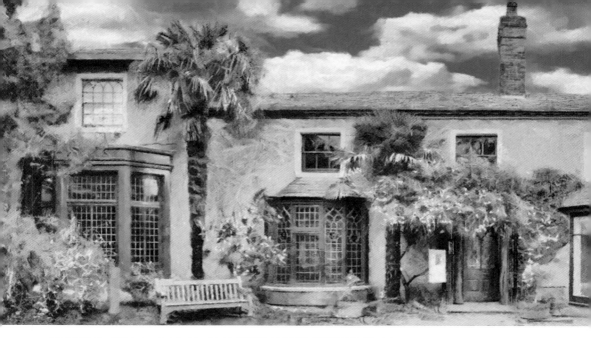

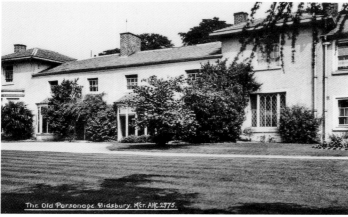

The Old Parsonage. Didsbury. Mcr. AHC.2775.

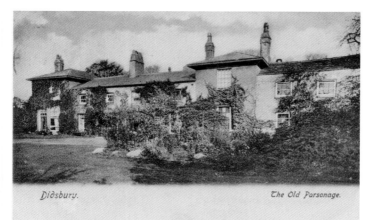

Didsbury. The Old Parsonage.

The Home of Fletcher Moss for Most of His Life

The Didsbury Parsonage was at one time the old parsonage, and is a Grade II listed building situated opposite St James' church. The building and gardens were left to the citizens of the City of Manchester by Alderman Fletcher Moss, who had lived there almost all of his life. It was until the 1980s a branch of the City Gallery and is now run as a Trust, which aims to provide a much needed Community Hub for the people of Didsbury in a locally significant and magnificent setting. Offering the opportunity to see and use this Grade II listed building, and preserving it for the future.

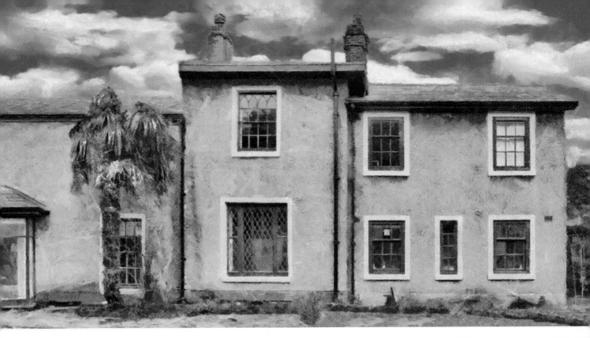

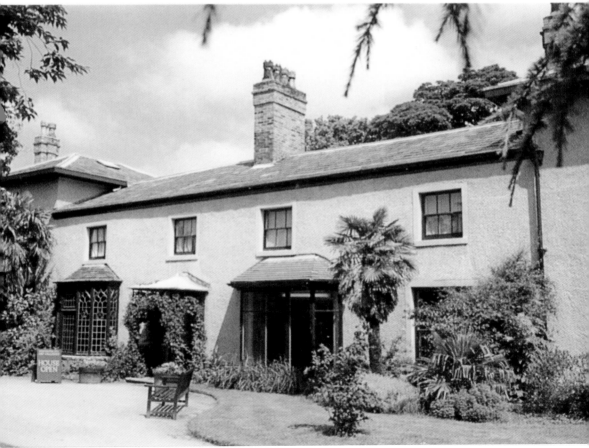

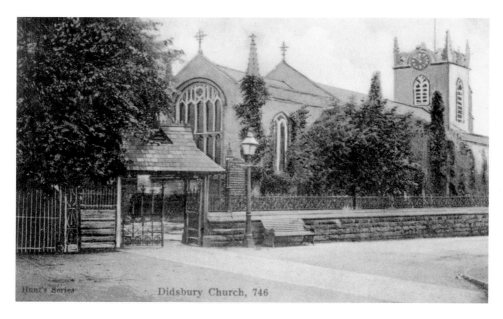

Hunt's Series · Didsbury Church, 746

From St Oswald to St James'

People have been worshipping on the site of St James' church from 1235 and some sources suggest even earlier. It was suggested by Fletcher Moss that it originally went under the name of St Oswald but was renamed St James' in 1855. Like many old churches, it has additions dating from the seventeenth and nineteenth centuries.

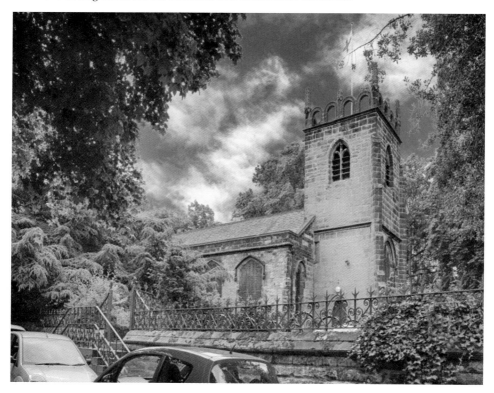

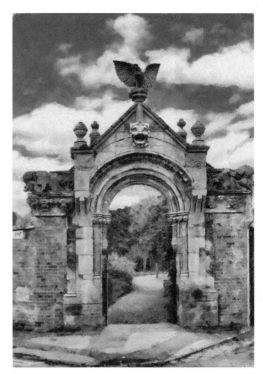

The Gateway to The Parsonage
I like the idea that the Parsonage Gate was once the entrance to the Spread Eagle Hotel on Corporation Street and was bought for £10 by Fletcher Moss when the place was demolished. Sadly, the eagle from the roof of the hotel, which resided in the gardens, has disappeared.

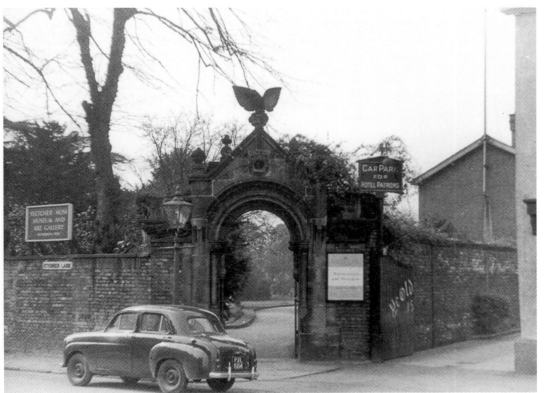

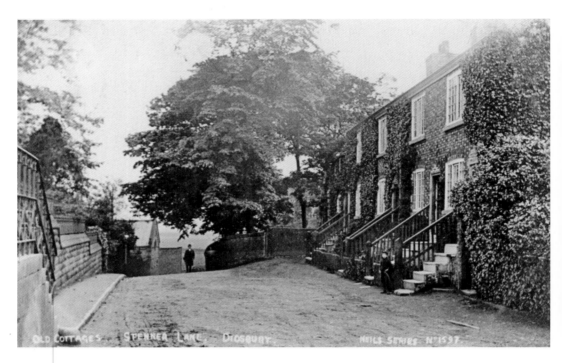

The Handloom Weavers' Cottages on Stenner Lane

These cottages on Stenner Lane were there by the early nineteenth century, and at least one shows up on maps from the late eighteenth century, but sadly they had gone by the 1930s. They appear on a number of different series of postcards that were regularly sent during the early 1900s.

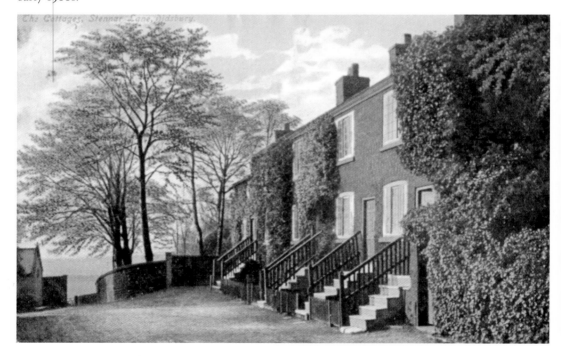

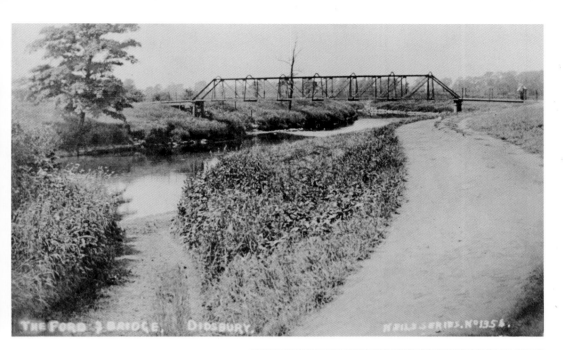

THE FORD & BRIDGE, DIDSBURY. NEILS SERIES. No 1356.

Henry Simon Built this Bridge Around 1910

There were several places around Didsbury where the River Mersey could be crossed by a ford, including the Cheadle ford and the Northenden ford. There was also the ferry at Northenden and, like the one operated at Jackson's Boat further west, the income from ferrying people across was a profitable undertaking. The Northenden ford was still in use until 1901 when Henry Simon paid for the construction of a cast-iron bridge.

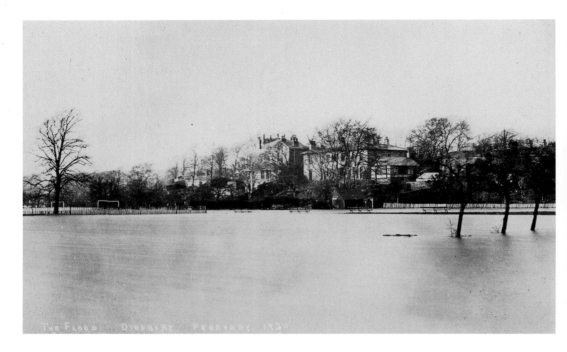

Of Floods and Sudden Mishaps

The price of living beside the River Mersey is eternal vigilance, because the river remains a powerful reminder that even the most benign and gentle water course can turn dangerous. The Mersey was also notorious for not only flooding but doing it with little warning. On one occasion, a farmer just managed to free his horse from the wagon and make it to higher ground, averting a disaster by just minutes. For centuries, those who lived beside the river sensibly built beyond the floodplain but, even so, the Mersey can still surprise as it did on this winter's day.

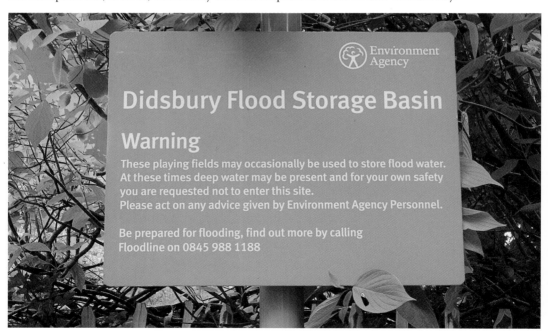

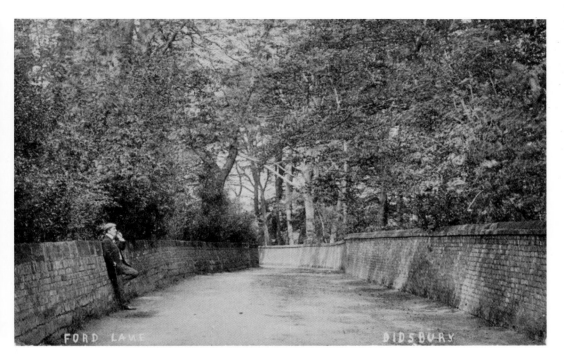

FORD LANE DIDSBURY

Was He Just There by Chance or was He a Prop to Enhance the Shot?

How do you enliven a picture of an empty country lane on a summer's day around 1900? Our commercial photographer solved the problem by getting his assistant to pose leaning against the wall with pipe in hand. Not the zippiest of scenes, but sufficient for it to be turned into a postcard and be sent by M. to her friend in Colwyn Bay in 1900, but even M. failed to comment on the scene. I suppose our photographer could also have included the flowers growing beside the lane wall, but I rather doubt M. would have been any more impressed.

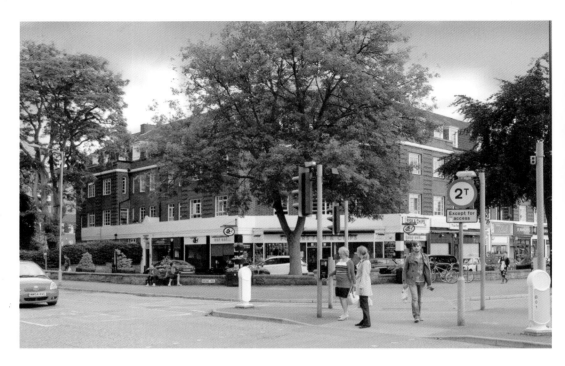

Lansdowne House, Which Some Believed Was Haunted

The house takes its name from the house that had stood on this site. This was a fourteen-roomed property set in its own grounds and bordered by South Road, Wilmslow Road and Ford Lane. It was there by the 1820s, when according to Fletcher Moss it 'was the haunted Swivel House now grown into Lansdowne House'.

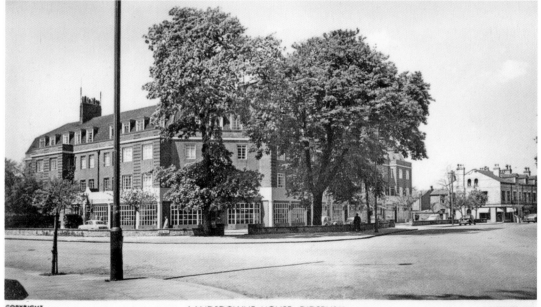

LANDSDOWNE HOUSE. DIDSBURY

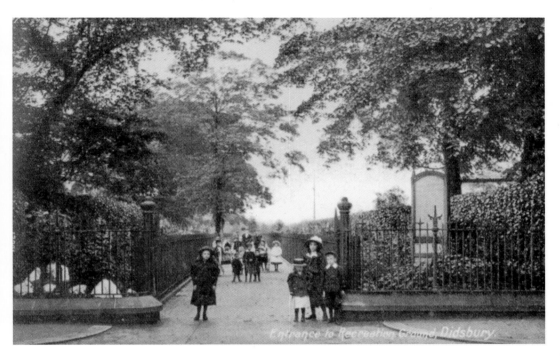

The Iron Railings Along the Long Entrance Were Never Replaced

Pretty much everyone knows the story of how during the last war all the railings were taken for the war effort. It is questionable just how useful an exercise this was, given the quality of the metal, but it was nonetheless one of those moments when people felt they were all in it together. That said, the entrance to Didsbury Park on Wilmslow Road is not so different, despite the century that separates the two images. The park had once been a field and was one of the first municipal parks in the city.

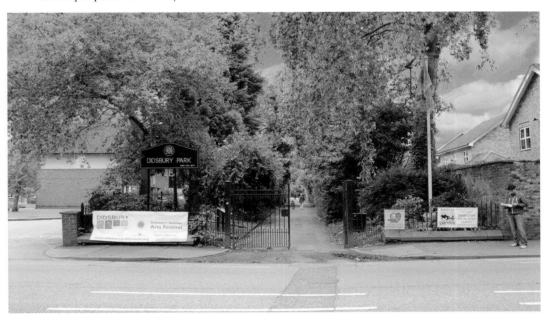

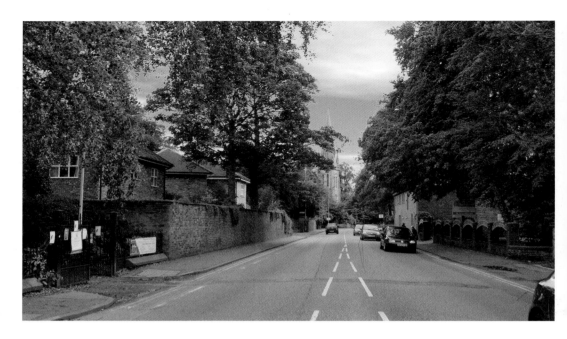

Bertha Geary and the Flying Man or 'We saw the Flying Man'
Now the scene is not as important as the message on the back, for Bertha Geary, aged just thirteen of School Lane, has heard history: 'We saw the flying man on Tuesday night fly overhead. Beaumont is his name. I wish you could have seen him. It made such a noise.' He was André Beaumont and he was one of thirty competitors in the *Daily Mail* Circuit of Britain Air Race in 1911. Flying in a Blériot XI, he was the first to complete the course, which was no mean achievement as many of the aircraft either failed to take off or crashed along the way. So the £10,000 prize went to him.

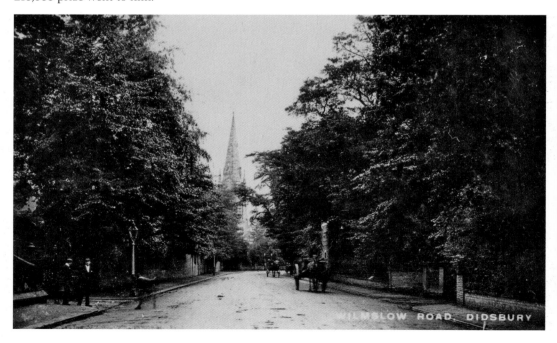

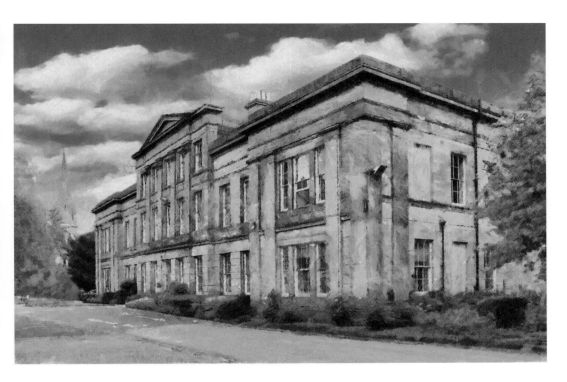

Commonly Known as The Pump House

I often wonder how many of the students and teachers who passed this building realised that the elegant stone façade was only added when it was bought by the Wesleyans in 1841 and became a theological college. The original house, with its red-brick walls and known as the Pump House, was built in 1744 and remained a private residence until early in the nineteenth century when it became a boarding school.

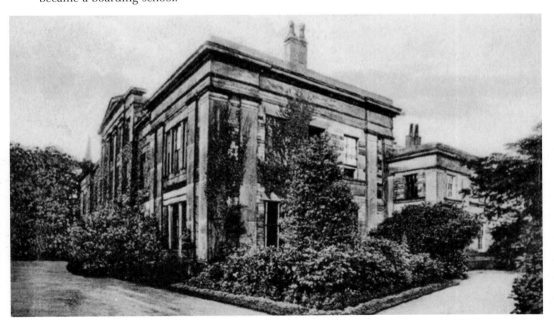

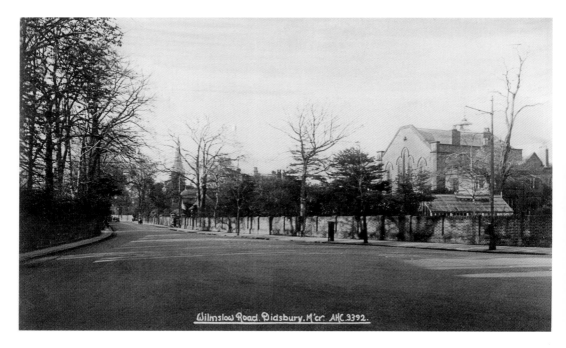

Wilmslow Road. Didsbury. M'cr. AHC 3392.

From Chapel to Library and Even a Hospital

The red-brick chapel on Wilmslow Road has been many things in its long history. First, it was as a chapel, a lecture room and library for the students training for the Ministry and, after a short time as a hospital, once again became a library.

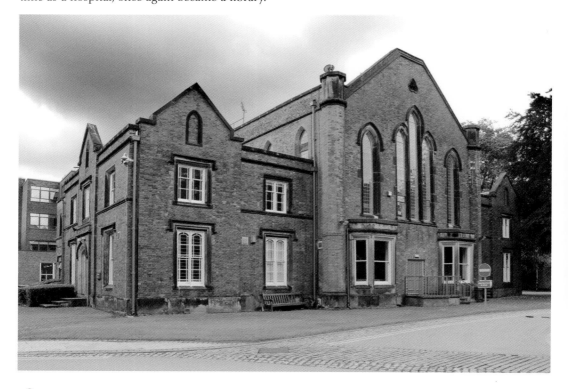

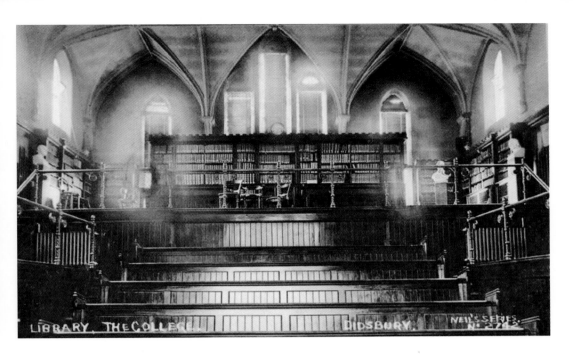

Originally Built as the Wesleyan Theological Institute

The interior of the library of the old Wesleyan College is still an impressive place. The huge windows, which are no longer obscured by bookshelves, allow the maximum amount of light to penetrate into the main area.

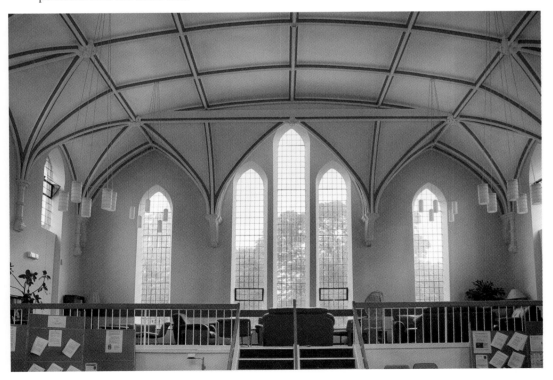

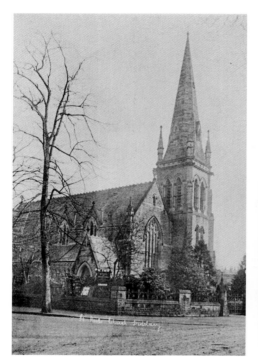
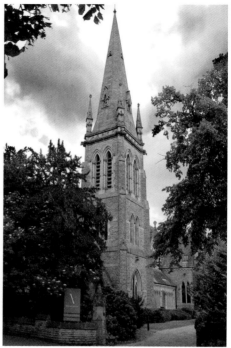

Now the Home of an Advertising Agency, St Paul's Stands Tall Above the Trees

St Paul's on Wilmslow Road is still an impressive sight and, looking at old pictures, it is easy to see how proud local Methodists must have been at its completion in 1877. Even now, as you head south along Wilmslow Road, past the brick wall of Broome House, the church with its tall spire catches the eye. However, despite its commanding position, changing patterns in religious worship have meant that it now has a secular use as the home of an advertising company.

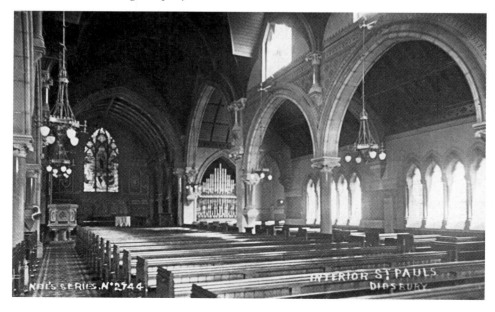

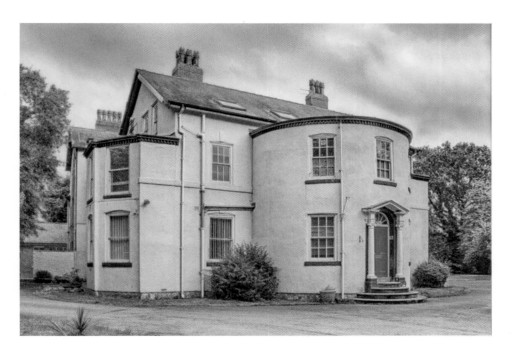

Broome House and a Gift to the Children of Didsbury

This is one of the oldest houses in Didsbury and has variously been home to the good, the wealthy and those who went on to build bigger and finer properties. Part of the grounds was sold in 1894 to the Local Board of Health for Withington for a recreational grounds, which sit behind the narrow path from Wilmslow Road.

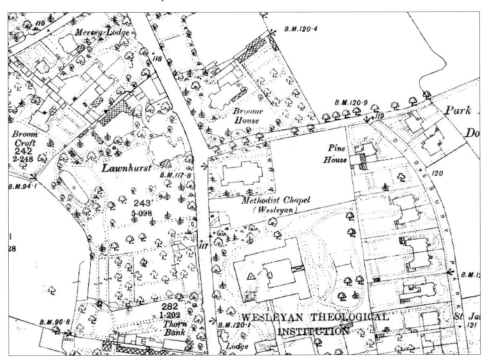

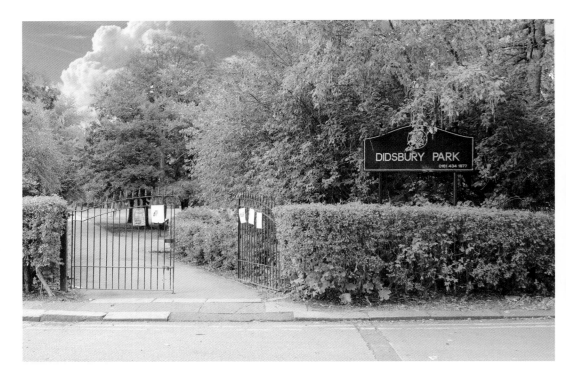

'A Long and Bitter Struggle for the Village Children to Have a Field to Play in'
Didsbury does quite well for parks and open spaces compared to some parts of the city, but it was not always so. According to Fletcher Moss, there had been those who 'long felt that the village children should have a field to play in, and one had been bought by the Local Board after a long and bitter struggle', which was opposed by those who thought it a fad and a waste of money.

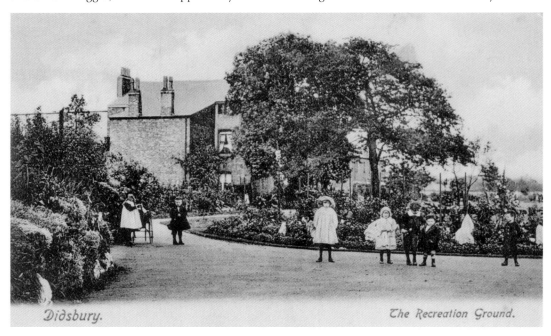

Didsbury. The Recreation Ground.

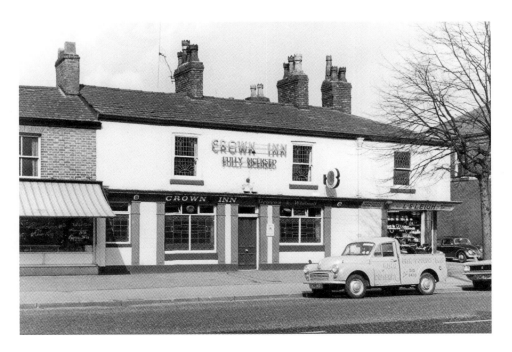

What was Once the Crown is Now the Famous Crown

The Crown has not always occupied the entire block from York Street down to the new-build. Back in 1911, it was just the central property comprising eight rooms, and was run by the forty-nine-year-old Albert Eggleton, who was a widow. Next to him at No. 118 were John and Kate Booth, who described themselves as shopkeepers of mixed business, while on the other side at No. 122, Mr Bourne, the tailor, had left sometime between December 1910 and April 1911.

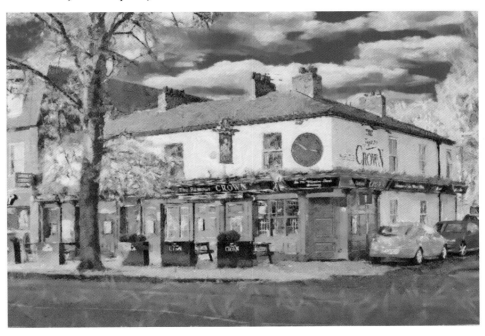

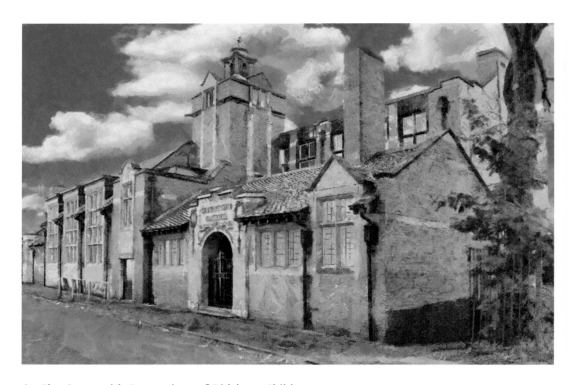

On Elm Grove with Generations of Didsbury Children
There has been a school in Didsbury since the early seventeenth century in different locations.
The present building on Elm Grove was constructed in 1880, with the addition of a girls' school
and classrooms for infants in 1911.

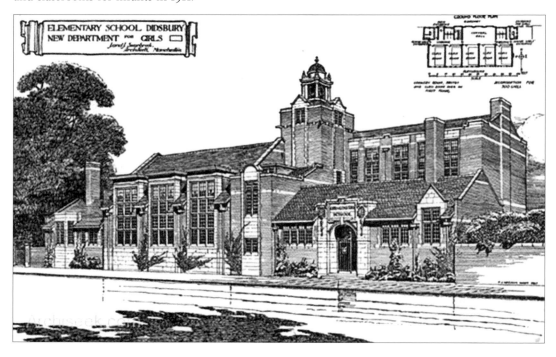

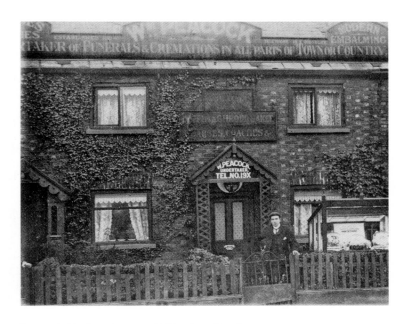

Peacock Undertakers on Wilmslow Road

The building that was once Peacock's Undertakers served the community for a century and more, but it was eventually torn down and replaced by a block of shops and offices. The picture dates from sometime in the first decade of the twentieth century. William Peacock, whose name appears above the door, died in 1908 and is buried with two of his children in Southern Cemetery, leaving his wife, Jane, to carry on the business, which offered 'Modern Embalming, Funerals and Cremations in all parts of the Town and Country'. They were listed in the telephone directory by 1906, which was also the year that Albert, the eldest son, married Annie, and sometime during that decade, they moved into the cottage next door to the family business. This was No. 76 Wilmslow Road and consisted of four rooms. Jane occupied Nos 78 and 80 with her other four sons, all but one of whom were in the family business.

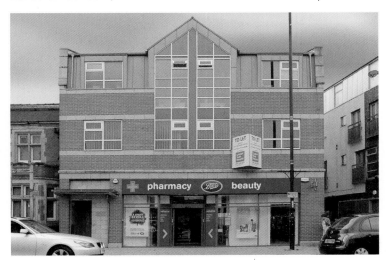

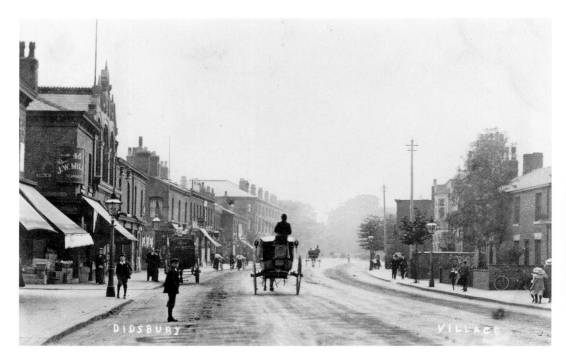

A Postcard Sent at 8.15 p.m. Would Arrive the Next Day

This is Wilmslow Road at the junction with Kings Lynn Close, which was then called King Street. The date on the postcard is 1922 and Mary had posted it at 8.15 p.m., confident it would arrive the following morning.

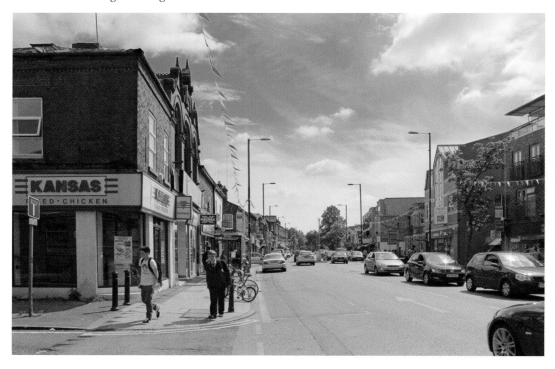

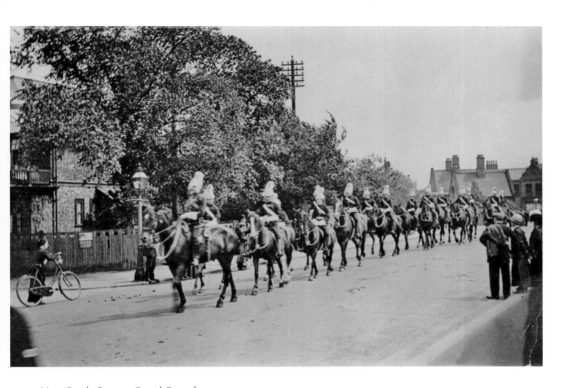

You Can't Beat a Good Parade

On Wilmslow Road, opposite what is now King's Lynn Close, the crowds turned out to watch the procession, and the shopkeepers have done their bit with bunting, flags and window displays. The prize for the best goes to Charles W. Owen, the draper at the end.

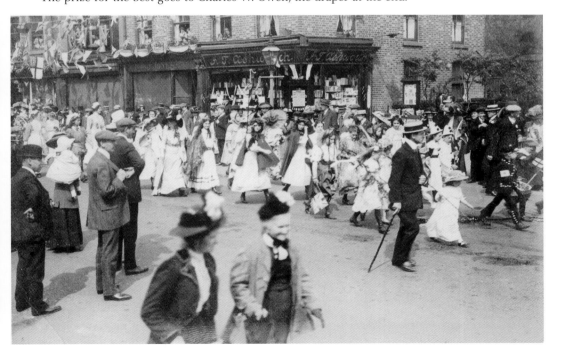

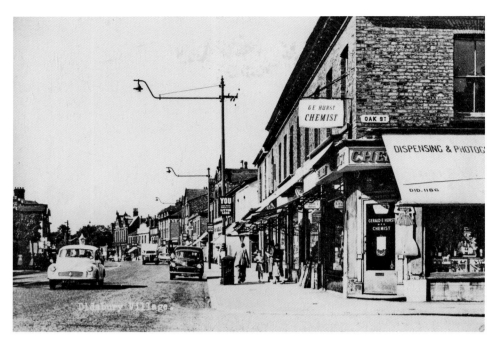

Five Years After the Second World War, the Shops are Looking Run Down

It is one of those odd things that the images of our high streets from the more recent past seem, in a way, more dated than those taken at the start of the twentieth century. So here we are on Wilmslow Road, at the junction with Oak Road, sometime in the 1950s, and the cars and van immediately take you to a moment that is not quite now. The modern signage along the side of the chemist shop looks unfamiliar, as does the cardboard cut-out in her summer swimsuit advertising Kodak Films, while the rest of the shop looks more than a little tired, as do its neighbours, as if the modernisation just ran out of steam.

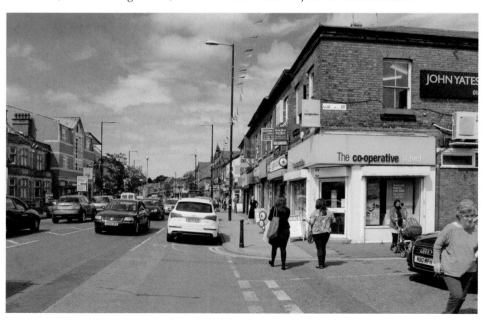

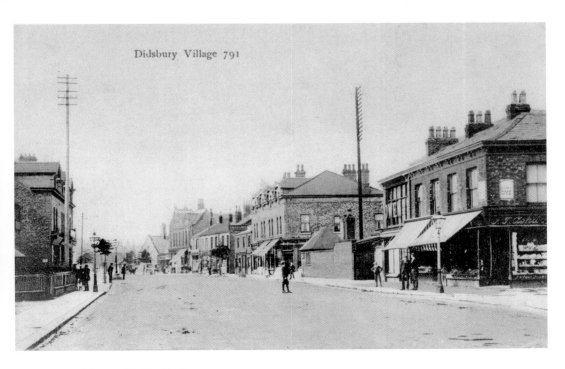

Didsbury Village 791

No Problem with Traffic in 1911

The block directly in front of us contained Mr Ashworth's stationary shop, Joseph Jones fruiterer, and Charles Own draper, with the coal yard of the Bridgewater Collieries on the corner by Hardman Street. None of these buildings have survived, although the National Coal Board retained a presence on the corner of what was Hardman Street and is now School Lane well into the 1950s.

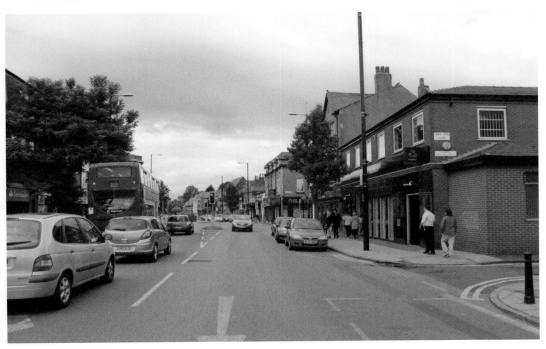

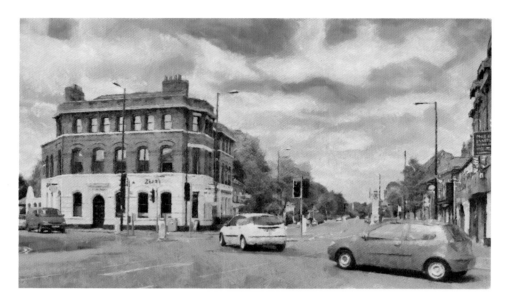

An Iconic Landmark Still Standing

The Wellington Hotel has dominated the corner of Barlow Moor and Wilmslow Road for a long time, and more recently it has had a number of name changes. Now I am unsure of the date of the picture, but it will be before 1911 because the Clock Tower, which was built in that year, is missing from the photograph. Sadly, the postmark on the reverse is blurred so we cannot be sure when G. P. who lived on Grange Road sent the card to Miss Steward of Old Trafford apologising for 'not being in touch' because 'I have been too busy going out to do much writing'. But a hand-coloured version of the card was sent in January 1904, with the revealing message, 'You remember this don't you Honey? Tom's place is round by the butcher's shop opposite the Wellington Hotel', which might place Tom on Hardman Street.

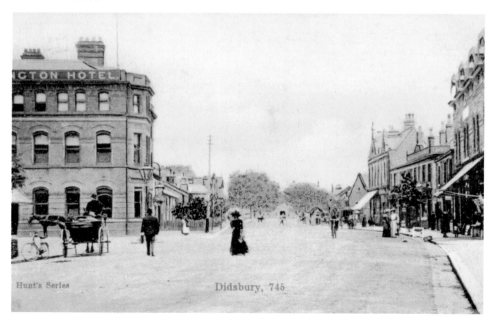

Hunt's Series Didsbury, 745

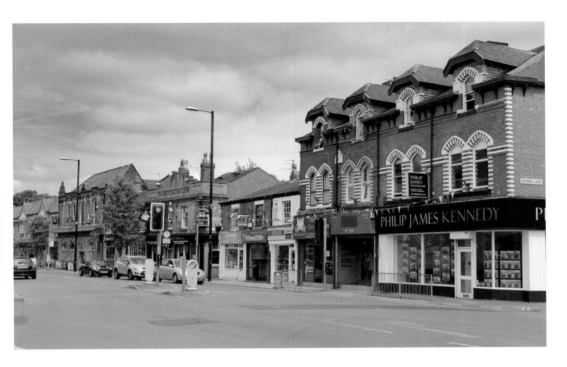

Before we had a Railway

This is a picture of Wilmslow Road that has long since passed out of living memory. We are looking north, roughly from the junction with Barlow Moor Road and the modern School Lane. The railway has yet to arrive and so it is just possible to make out the line of cottages just beyond where the curious crowd looks back at the photographer.

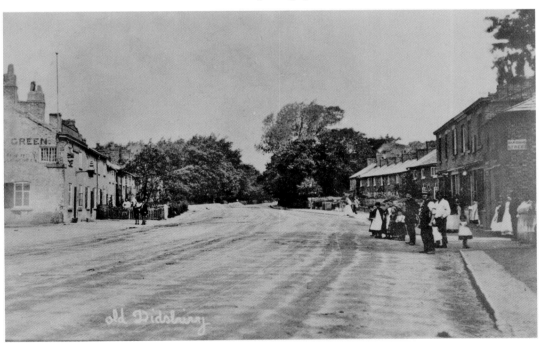

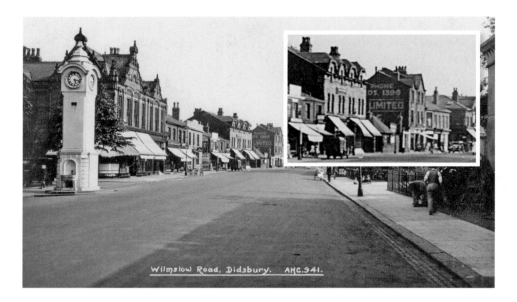

Wilmslow Road, Didsbury. AHC.941.

Signs of Businesses Long Gone

Ghost signs are by their very name hard to find these days. They are the painted signs of businesses that have long since gone, leaving only a fading record of what was once traded from the premises. This one is in Didsbury on the corner of Wilmslow Road and School Lane, and advertised the cabinet-making business of Thomas Spann, who operated from Nos 35 and 37 Wilmslow Road, which are now a coffee shop and bookmaker's. Originally the sign read 'TEL, 234 DIDSBURY, SPANNS, BLINDS, REMOVING, CARPET LINOLEUM & BEDDING WAREHOUSE'. The Spanns were here from the early part of the twentieth century, and what we see now was not what Thomas Spann would have been familiar with. In 1911, in front of the gable end that fronts what is now the side of School Lane, was the coal yard and offices of the Bridgewater Collieries, and our ghost sign extended almost down to street level.

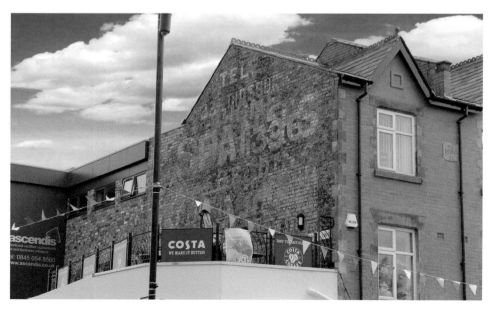

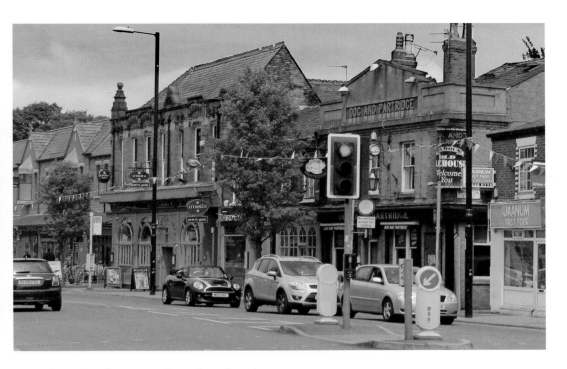

Changing Shops to Reflect Changing Times

This is one of the sets of pictures that together sum up the transformation of Didsbury. In 1911, a commuter fresh from the train had a pick of shops to buy last-minute items, including groceries, tobacco and even a haircut, before heading home after a quick glass of stout with Mrs Cochrane in the pub. Today, most of the same stretch is comprised of either restaurants or bars, which pretty much points to how other parts of Didsbury have gone.

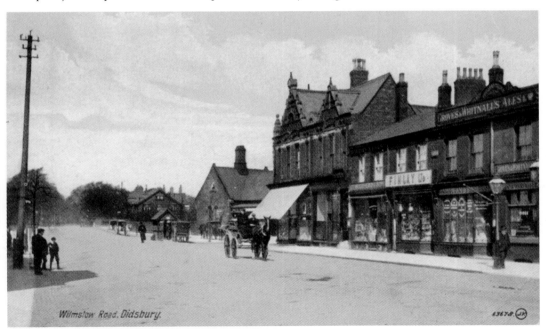

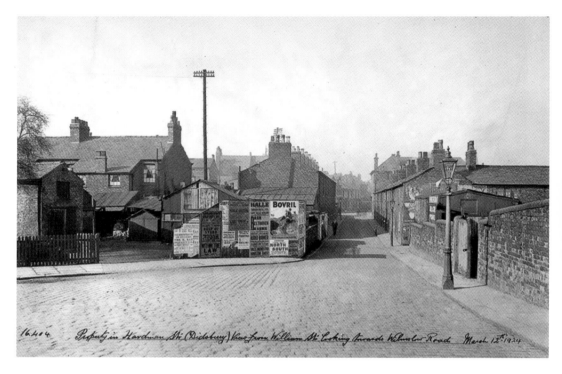

On Warburton Street, an Echo of Hardman Street and a Vanished Way of Life

We are on Hardman Street in March 1924, and among the adverts is the announcement of the films *Reef of Stars* and *Within the Law*, both showing at the cinema in Elm Grove round the corner. Hardman Street disappeared when School Lane was extended to Wilmslow Road, but something of just how narrow it was can be obtained from standing in Warburton Street, which runs parallel.

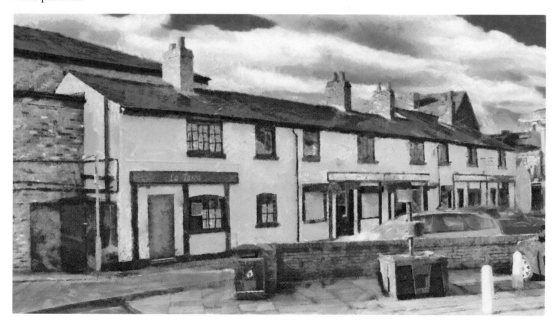

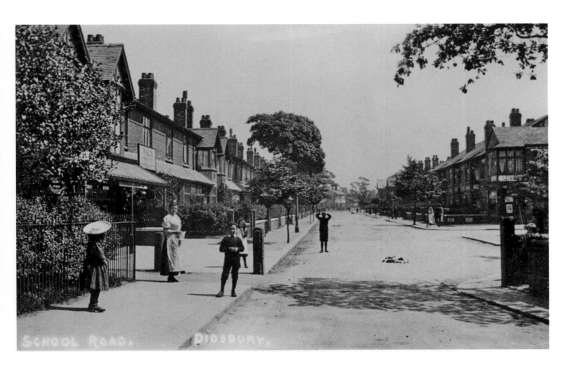

The Supper Bar Kept its Name from 1911

We are on School Lane and the year is sometime around 1911, and I am drawn to the people in the picture. I doubt that we will ever be certain who the woman staring back at us is, but I rather think it will be Mrs Martha Meredith, who ran The Supper Bar (Fish and Chips). She described herself as a widow, with a fourteen-year-old daughter sharing her home with her brother-in-law, as well as Mary Ann, who she employed as a servant and John Wilson the boarder. The properties are still recognisably the same and by one of those odd coincidences, just 102 years after our picture was taken, No. 1 is still a fish and chip shop.

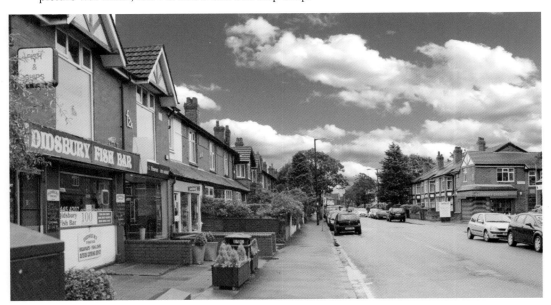

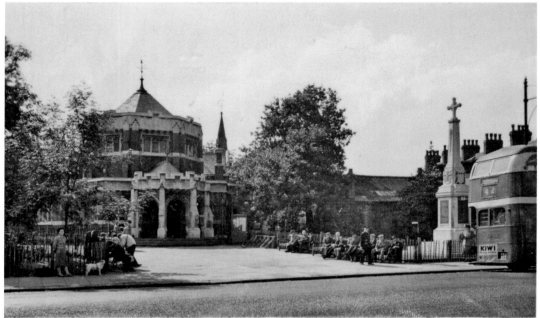

WAR MEMORIAL AND LIBRARY, DIDSBURY

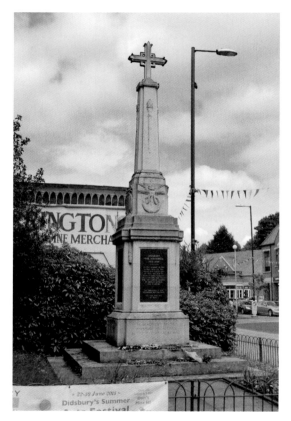

Remembering the Dead of the First and Second World Wars

The war memorial by the library records the 241 men from the First World War and the sixty-seven from the Second World War who died in those two conflicts. I like the simplicity of its design, which matches the inscription:

TO THE MEMORY OF THE
SACRED DEAD OF THIS
VILLAGE, WHO HAVING LEFT
ALL THAT WAS DEAR TO
THEM, ENDURED HARDSHIPS,
FACED DANGERS AND FINALLY
PAID THE SUPREME SACRIFICE
IN DEFENCE OF KING
AND COUNTRY

"LET THEIR NAMES BE EVER
REMEMBERED WITH GRATITUDE"

"MAY THEIR SOULS
REST IN PEACE"

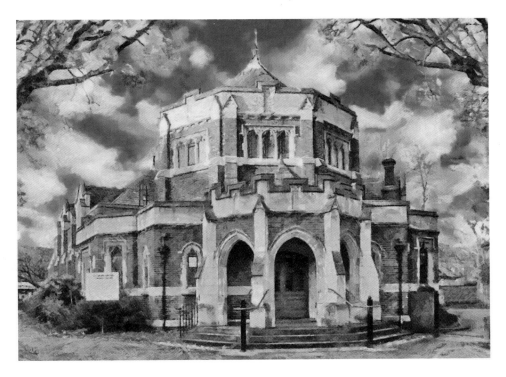

A Brand New Library, Fit For a New Century

Didsbury's library was built in 1915, and was a brand new library fit for a new century. Its outside was in the words of its architect 'designed in the fifteenth-century gothic style with tracery windows and emblems of Science, Knowledge, Literature, Music and Arts and Crafts in stone distributed over the building'. The walls were tiled to dado height, the floor cork carpeted and the oak furniture, fittings and partitions were all supplied for £600.

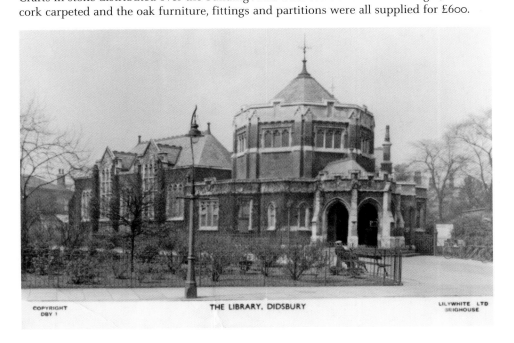

COPYRIGHT
DBY 1

THE LIBRARY, DIDSBURY

LILYWHITE LTD
BRIGHOUSE

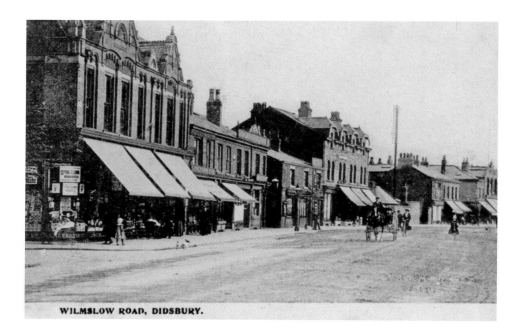

WILMSLOW ROAD, DIDSBURY.

Seymour Mead, One of the First Chain Stores

This corner of Wilmslow Road was dominated by one of the branches of T. Seymour Mead, the grocery chain. Like all the grocery shops of the period, the window is plastered with adverts for products and inside those very products would fill the shop, reflecting that simple business maxim of 'pile 'em high, sell 'em cheap'. Now I know the postcard was sent in 1905, but I am not sure of the year the picture was taken; it may have been in spring, given the frequent reference in the adverts to spring cleaning and sponges. This takes us back to a time when spring cleaning was a big thing and undertaken almost as a special event to mark the end of winter and the end of those dirty coal fires.

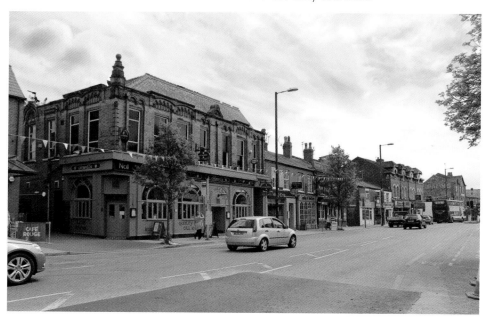

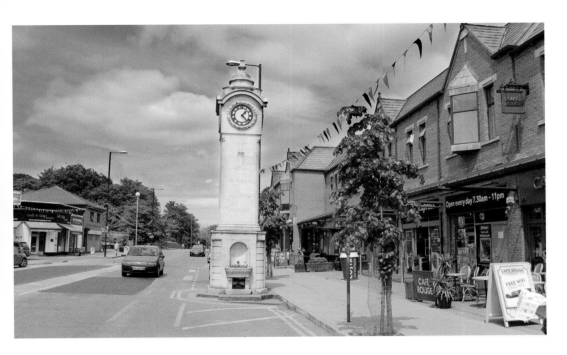

The Milson Rhodes Memorial

The clock tower is one of the enduring landmarks in Didsbury. It was unveiled in 1911 and is dedicated to the memory of Dr John Milson Rhodes, who was a GP in Didsbury from 1874 until he died in 1909. He was active in the civic life of the community, making much needed reforms to the way the workhouse treated its inmates and patients. Our picture dates from no later than 1930, when a D. Thomas sent it to his mother in Wales and chose to write the message in Welsh.

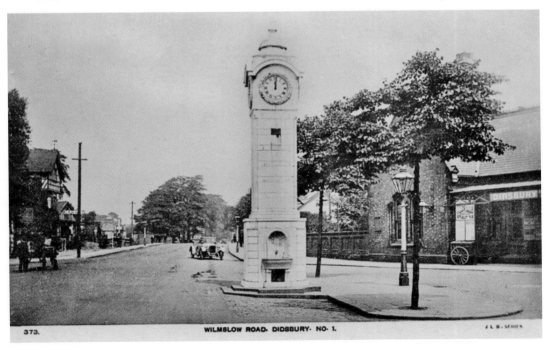

373. WILMSLOW ROAD. DIDSBURY. NO· 1. J L B · SERIES

Catching the Train to Town for Work or off to the Peak District for a Weekend Break
Didsbury Railway was opened in 1880 and was part of the line that took you from Central station, south to Buxton and on to Derby, Sheffield and London. By 1900, over 200,000 tickets were sold from the station and, a decade later, Didsbury was served by thirty-eight trains running south and forty running north with a frequency of every ten minutes at peak times. It closed on 2 January 1967. Looking at the old photograph, there must be a train due, judging by the number of horse-drawn cabs and carriages waiting at the station entrance. Today, the site is given over to bars and restaurants, but just a little further south along the old railway line is the new metro stop of Didsbury Village, and I rather like the idea that once again there is a fast and direct route into the heart of the city.

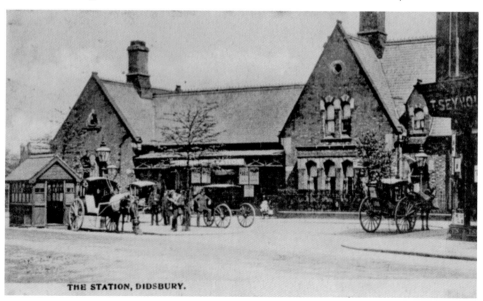

THE STATION, DIDSBURY.

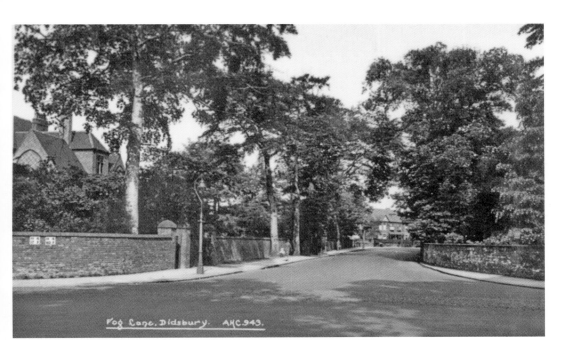

Fog Lane, Didsbury. AHC.943.

Along Fog Lane as the Big Houses Vanish

It is a scene that has changed almost beyond recognition, and points to the development of the classic semi-detached, suburban house that spreads out over what had once been the estate of Didsbury Priory, which is directly to our right. It also marks the demise of those bigger houses, like the one on our left, which were costly to run and needed servants.

A Brewer at No. 10, Wilmslow Road

Now, when Henry Hubert Hawkins settled into No. 10 Wilmslow Road sometime at the beginning of the twentieth century, I rather think he was quite pleased with himself. He was a brewer by occupation and had moved around the country, but this was the first place with views across open land, for on the other side of Lapwing Lane there were no houses. Less than a decade earlier and he would have had a clear view south, all the way to Parkfield Road and on to where the railway crossed Wilmslow Road, while from what was now his front garden, there would have been a glimpse through the trees of Didsbury Priory.

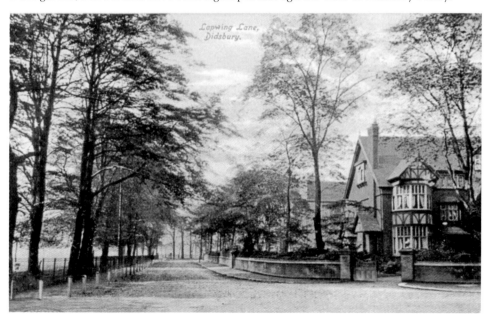

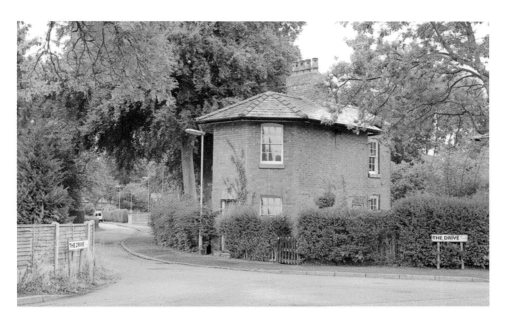

All That Remains is the Lodge and a Street Named After its Winding Drive
It is remarkable just how many of Didsbury's fine old houses have survived and even if the big house has gone, there are still the outbuildings and grounds to bear witness to where they once were. This is the lodge of Catterick Hall, which stands on the corner of Fog Lane and The Drive. The hall dates from 1805 and was only demolished in 1966. It stood in 18 acres, was approached down a tree-lined avenue, which is now The Drive, and its extensive gardens contained a lake.

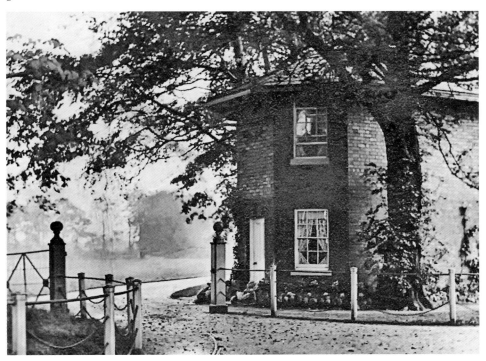

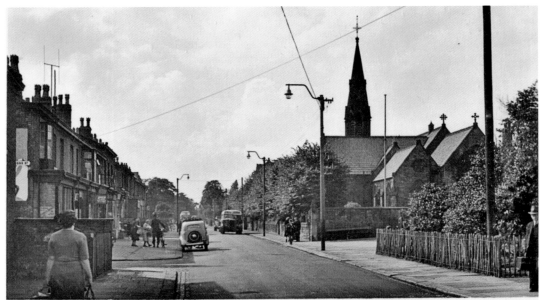

EMMANUEL CHURCH AND BARLOW MOOR ROAD, DIDSBURY

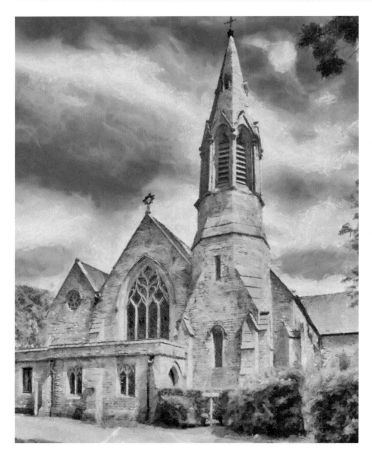

A Beauty Hidden Behind the Trees

Emmanuel church dates from 1858 and was enlarged sometime after 1872. Like many areas of South Manchester, the rising population led to a growth in the number of churches. In 1976, it was decided that the parish of Emmanuel should join with that of St James. Six years later, the pews at Emmanuel were replaced by chairs and the altar by a removable podium.

64

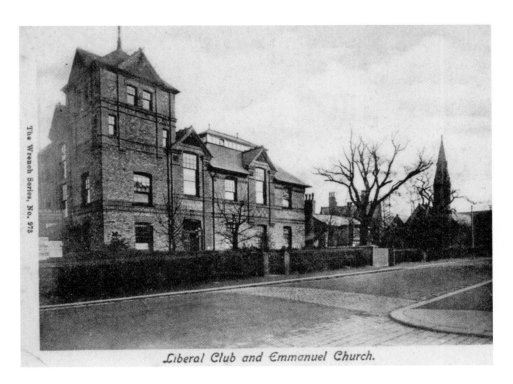

The Wrench Series, No. 973

Liberal Club and Emmanuel Church.

The Tall Tower Structure Offers a Commanding View Down Barlow Moor Road

This is the Liberal Club on the corner of Pine Road and Barlow Moor Road. Interestingly enough, it only became the home of Didsbury Liberals in 1899, having previously been the Conservative Club. It was extended a number of times during the next twelve years and, in 1911, during a ceremony to mark a further extension, the president, John Watt, remarked that since vacating the premises the Conservatives 'after having had two clubs now have none'. A century later, this fine old building is no longer a club, having been converted into flats.

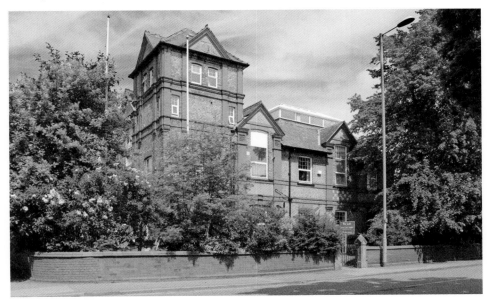

Ivy Cottage has Hardly Changed Since 1900

The Evangelical congregation of Didsbury has been worshipping on this site at the corner of Barlow Moor Road and Hesketh Avenue since 1900, when the present building was erected. Before that, for five years, services were conducted in a cottage opposite the present site that had been covered in ivy, and so gave a name to the new place of worship.

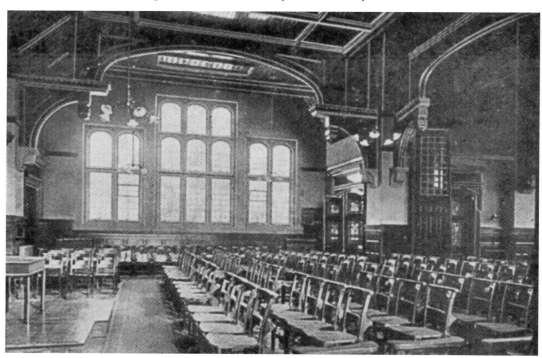

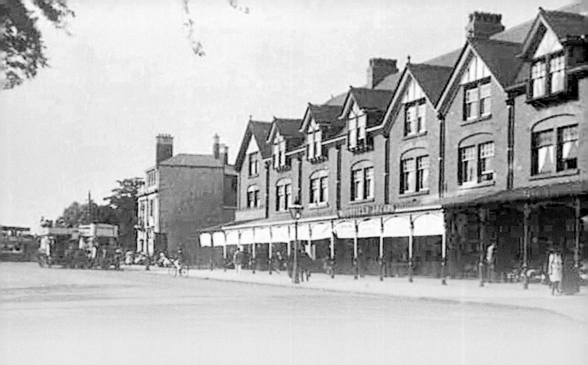

CHAPTER 3

Didsbury West

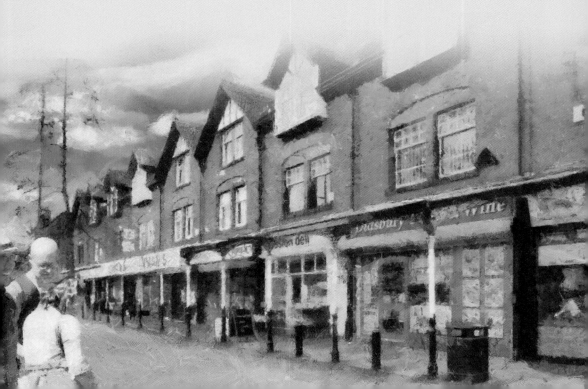

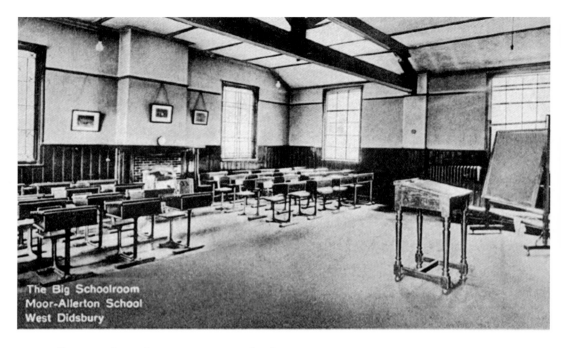

The Big Schoolroom
Moor-Allerton School
West Didsbury

Moor Allerton Independent Preparatory School

Private schools were big business in the late nineteenth and early twentieth centuries. There were 564 listed in the 1911 street directory for Manchester and Salford, and they ranged from small schools for young children to those specialising in certain subjects, and crammers designed to teach for certain examinations. In Didsbury there were fifteen, which was not as many as Chorlton just down the road, but more than Withington.

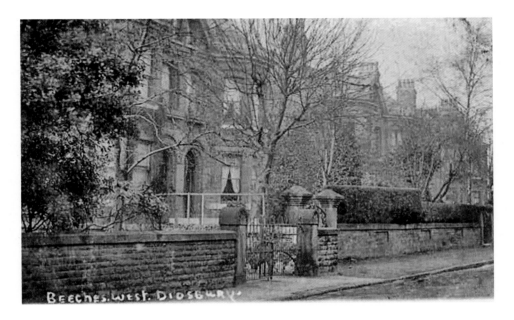

Beeches. West. Didsbury.

Solid and Comfortable Lives on the Beeches

Even today there is something very solid and very comfortable about the Beeches, which is one of those tiny quiet roads off Barlow Moor Road in the west of Didsbury. Back at the beginning of the twentieth century, the residents were very much the new Didsbury. Here were solicitors, a surgeon, and a stockbroker, along with an inspector of schools, two shipping merchants, a manager and two on 'private means'. Their occupation placed them in that comfortably well-off bracket, able to buy or rent these fine large houses and employ a host of servants. Their ten-roomed houses had been built just before 1894, and were within a short walk of the river and open land.

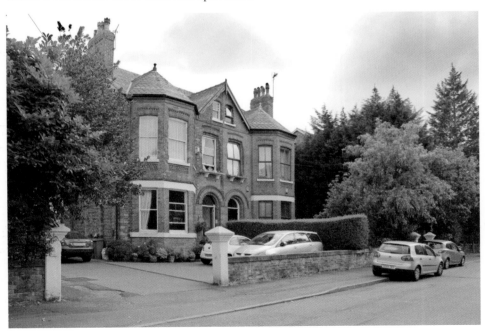

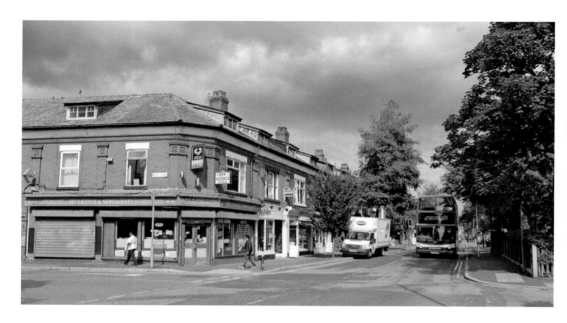

When Madam De Korti Sold her Artists' Materials on Burton Road

This photograph of Burton Road in the early 1900s is still easily recognisable. Then, as now, there is a grocer's shop on the corner with Nell Lane and the row of shops beyond it is as thriving now as they were then. Of course, what they sell has now changed, reflecting the way we shop. So, in 1911, Miss Ettie the tobacconist, along with Harry Cayton the butcher, occupied the parade with a cycle shop, a hairdresser's, a ladies' outfitter's, a dyer's and cleaner's, and Madame De Korti artists' material dealer. Today, there is more of uniformity about the stretch, which has more than its share of fast-food outlets and restaurants.

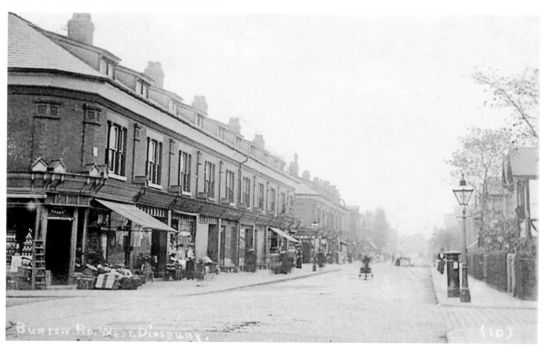

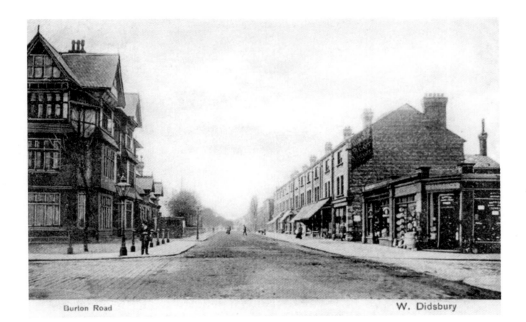

Burton Road W. Didsbury

Now Called The Metropolitan

The Midland Hotel on the corner of Lapwing Lane and Burton Road has dominated this spot for over a century. The owners may have changed its name and altered the internal layout to suit the tastes of today, but it is still a big place. Back in 1911, Francis and Hannah Tootell employed a staff of six to help run the fifteen-roomed public house. These included Mrs Dolan, the hotel cook, a barman and barmaid, a waitress and waiter, and a hotel maid, all of whom lived in.

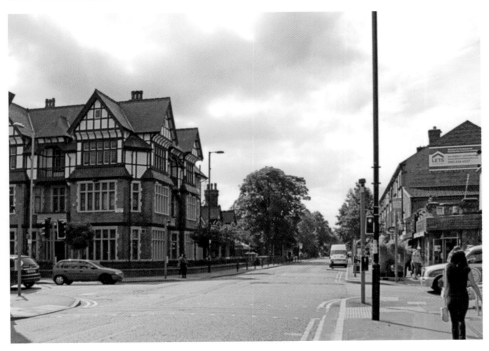

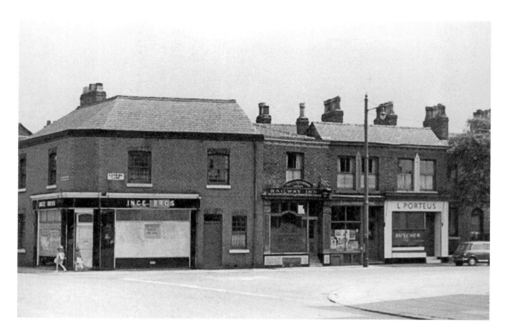

A Tiny Pub Across From the Mighty Metropolitan

At one time, The Railway Inn was the smallest pub in Manchester, but it has recently been extended to create a more open space. It was the watering hole of the late Alex Higgins. It was also claimed that Johnny Depp had been seen in the establishment, but this was later found to be a spoof when Johnny Depp lookalike Carmelo Masi, also known as Mel, duped everyone, including the press.

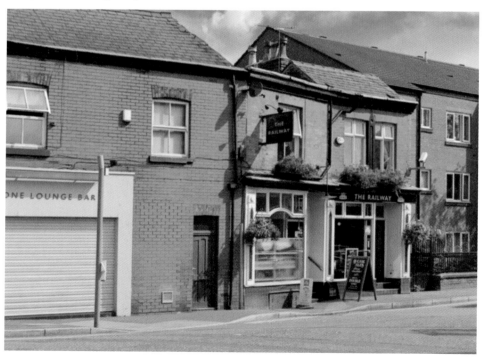

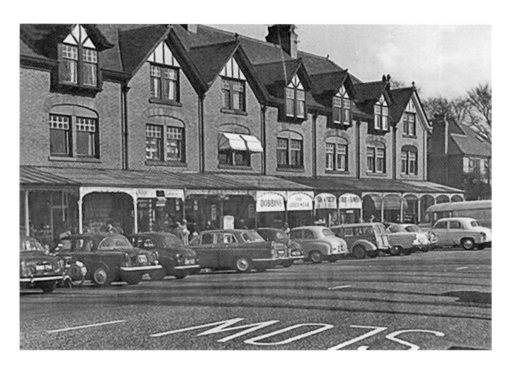

On Lapwing Lane With a Bit of Style

Once upon a time, every parade of shops of a certain standard boasted a glass and cast-iron canopy. They added a little style to the row and, of course, kept you dry in the rain. Most had ornate tracery and came with the name of the maker stamped on the base. It was not only the local row of shops, for cinemas and theatres also added that little bit of something extra, but most have either rusted away or been demolished by shopkeepers seeking a sleeker appearance.

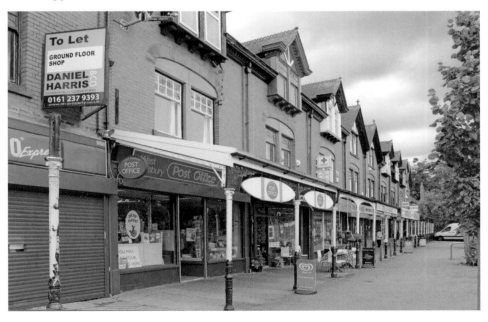

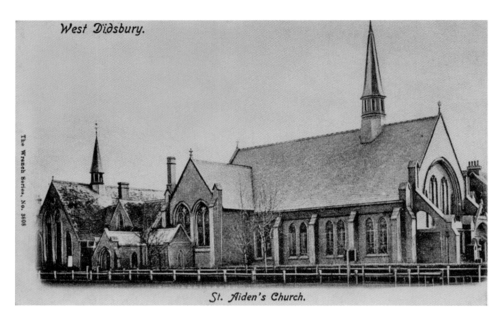

West Didsbury.

The Wrench Series, No. 3608

St. Aiden's Church.

A Grade II Listed Church With a Beautiful Stained-Glass Windows

St Aiden's Presbyterian church, now Didsbury United Reformed church, stands on the corner of Palatine Road and Parkfield Road South, and from the main road it is easy to miss just how large a building it is. It was opened in 1901 and is made with Accrington brick and Westmoreland slate. Of particular interest are those stained-glass windows made by the artist Walter Pearce, who worked on them from 1901 to 1913.

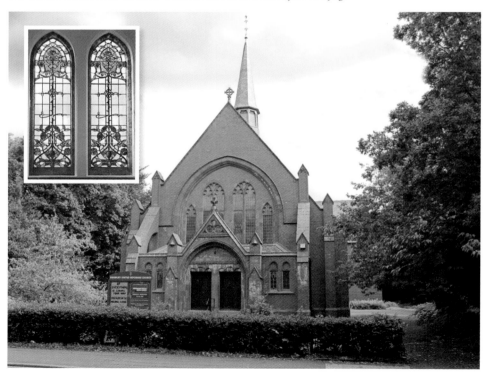

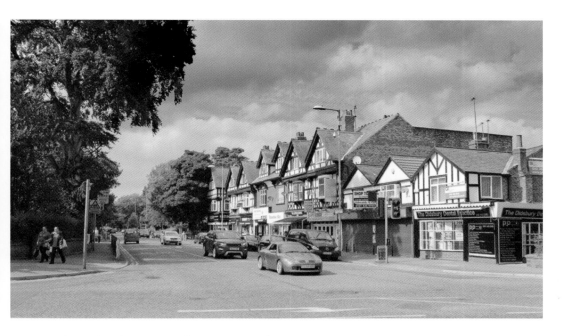

A Trip to the Shops on Barlow Moor Road

We are standing at the corner of Palatine and Barlow Moor Roads sometime after 1911. This was Tripps Corner, and is a perfect example of how popular names take root and defy even the planners whose alternative place names never quite catch on. So this is Tripps Corner because John Tripp, a grocer from Swansea in Wales, bought the plot of land stretching back from Palatine Road along Barlow Moor Road and built this parade of shops and houses. Now, one source suggests a date of 1910 for the purchase and development of this spot, but the census returns have John and his wife living there by 1881 and still there twenty years later.

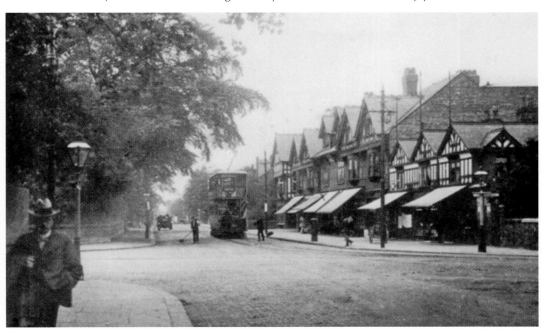

A Potpourri of Merchandise Nestling on the Corner of Two Busy Roads
Mr Tripp's shop sold groceries, lent books and contained the post office. His daughter ran the post office and may also have run the lending library. Many stationers, newsagents and post offices offered such a service.

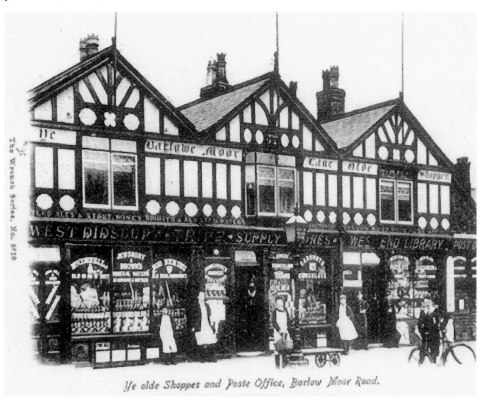

Ye olde Shoppes and Poste Office, Barlow Moor Road.

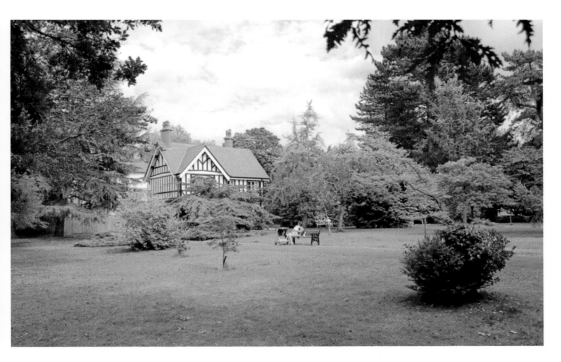

An Oasis of Peace and Seclusion in a Densely Populated Suburb

Marie Louise Gardens is one of those little gems hidden away on Palatine Road just south of Spath Road. It covers just over 4 acres, and has been delighting the residents of Didsbury ever since it was gifted by Mrs Silkenstadt in memory of her daughter, Marie Louise, who died of peritonitis on 20 October 1891, only three years after her marriage at the age of twenty-six.

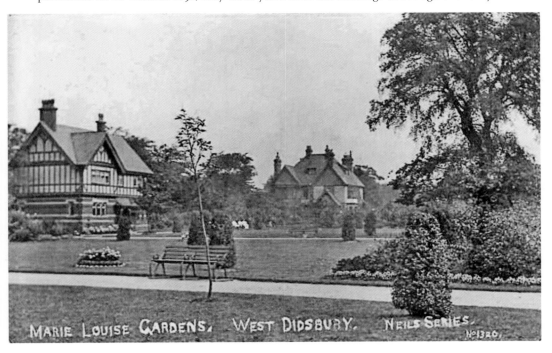

MARIE LOUISE GARDENS, WEST DIDSBURY. NEILS SERIES. No 1320.

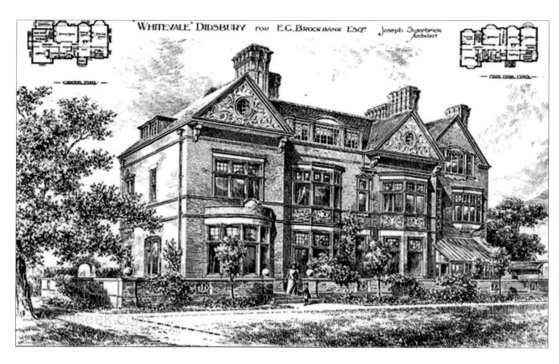

'WHITEVALE' DIDSBURY FOR E.C.BROCKBANK ESQR. Joseph Sugerbrick Architect

Edward Brockbank's Vision of a Comfortable Home

When Edward Brockbank built Whitevale in 1896, he did it on a grand scale. The house had twenty-two rooms and was set in open land, fronted by Spath Road to the north-east and an orchard to the south and east. He described himself as a metal merchant and lived at Whitevale for thirty-three years. He died in 1929, leaving over £80,000 to his wife.

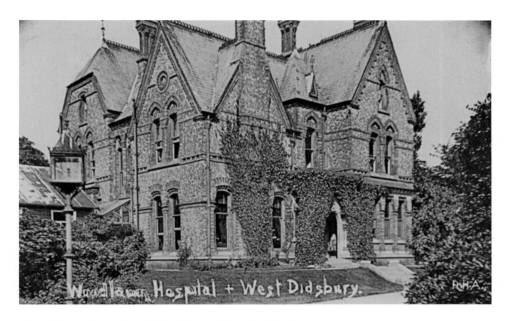

Wood lawn Hospital + West Didsbury.

Wood Lawn, Mrs Churchill's Gift to Wounded Soldiers

Wood Lawn was a large, fifteen-roomed house on Mersey Road. At the outbreak of the First World War, its owner, Mrs Laura Churchill, had offered it to the Red Cross as a hospital and it served as such until the end of the war. According to the *Manchester Guardian* of November 1914, 'twenty wounded soldiers were transferred from Whitworth Military Hospital [to this] large and pleasantly situated house which has been admirably equipped by the East Lancashire branch of the British Red Cross'. By 1916, there were six wards and the same newspaper reported that 'Christmas at Woodlawn was well celebrated'. Wood Lawn was one of many private houses and public buildings that were converted for such purposes. Just down the road, the Wesleyan College on Wilmlsow Road was turned into a hospital with 100 beds. At the end of the war, Mrs Churchill was awarded an OBE.

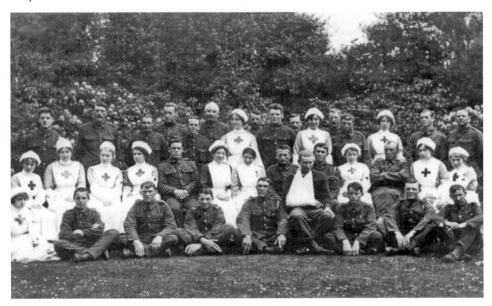

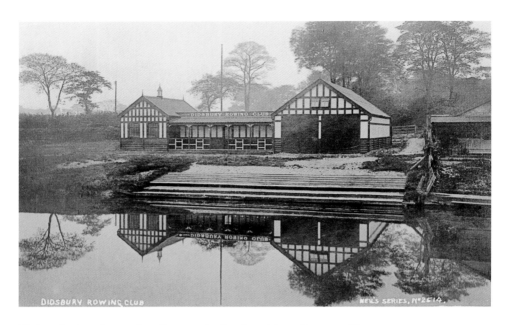

Today the Boathouse has Gone to be Replaced by a Caravan Site

The Didsbury Rowing Club was formed in 1850, and its most successful period was from 1866 to 1878 when it took part in many principal regattas. However, after 1878, interest waned and the club was wound up in January 1885, with the sale of all its boats. But in 1903, the club was revived and was so successful that, by 1909, a new clubhouse had to be built to accommodate a membership of over 100. The new boathouse opened on 28 August 1909, which attracted a large number of spectators who watched the thirty-four races that ran over six hours. I guess this photograph was taken not long after that event, as the postcard was sent in the summer of 1911.

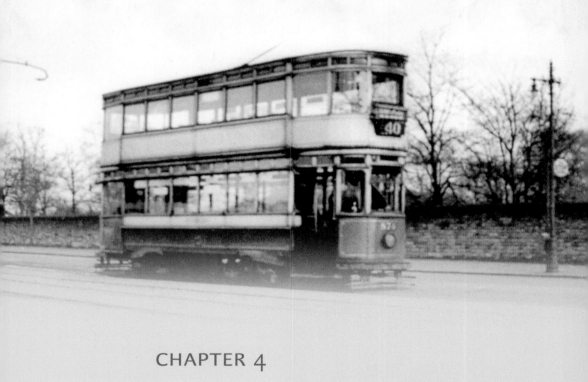

CHAPTER 4

Transport

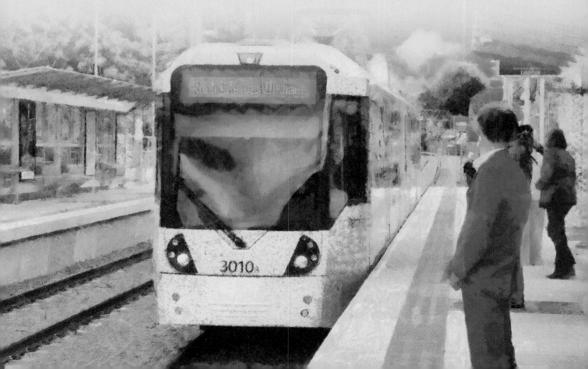

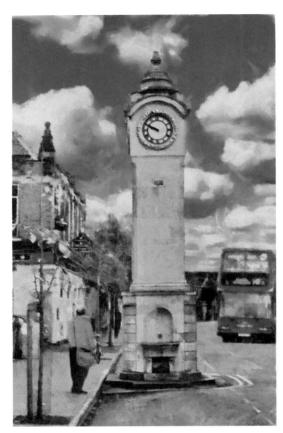

I Wonder Where Bus 42 Registration Number JNA 496 is Today?

The year is 1954, and on this summer's day, a No. 42 bus of Manchester Corporation makes its way north towards the city, having just passed Barlow Moor Road. I doubt that our 1954 photographer would have found it as easy to take the same scene today. The traffic that accompanies this 142 service of the Stage Coach Company thunders along the main road, only brought to a halt by the traffic lights at the junction with Barlow Moor Road.

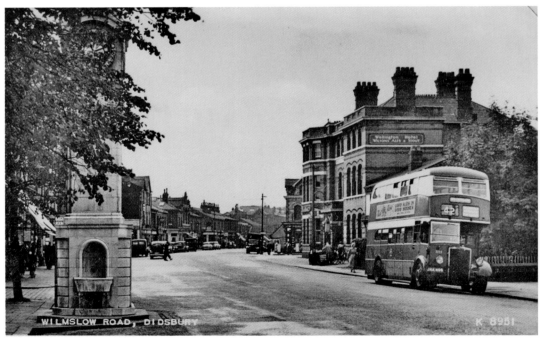

WILMSLOW ROAD, DIDSBURY

K 8951

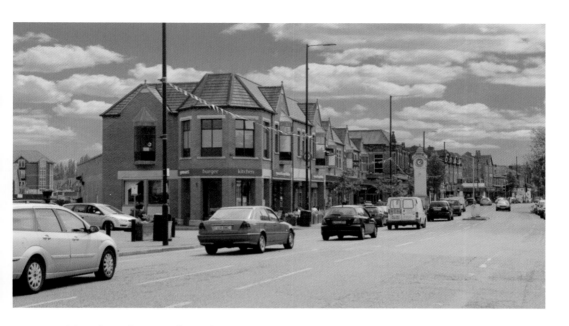

Catching the Cab Home from the Station

I would like to think we could identify one of the two cabs standing outside Didsbury railway station sometime in the first decade of the twentieth century. There were a number of cab companies in Didsbury and Withington, but the two who stand out as real candidates were Samuel Fildes of Millgate Lane and William Wrightham, who lived at No. 40 Wilmslow Road. Of these, Mr Wrightham's home was almost directly opposite the station, just ten doors down from the Wellington Hotel and roughly where the library now stands. Just a century later, his house, the cabman's hut, clearly visible in the picture along with the station, has gone, as have the horses, replaced by the speeding cars.

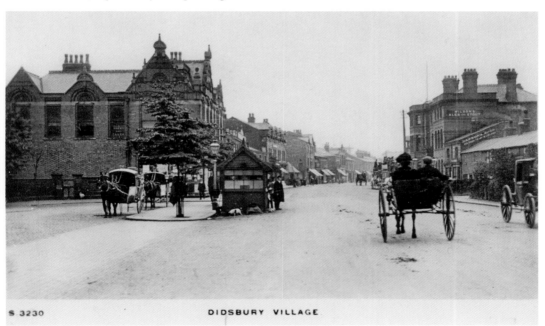

S 3230　　　　　　　　　　　　　DIDSBURY VILLAGE

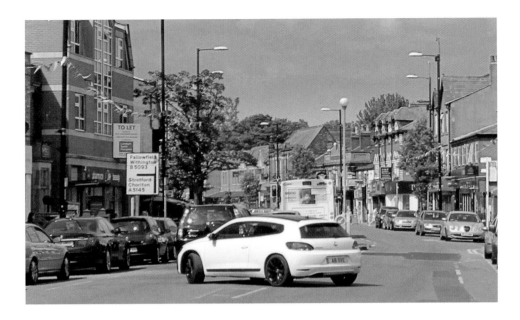

Of Horses, Carts and a Coal Man

What strikes you first is the number of horse-drawn vehicles of all descriptions, from heavy wagons to delivery vans, and by the cabstand next to the station there are the cabs. Then there is that handcart, which crops up beside roadworks and on construction sites. They might have been carrying a mix of tools, materials and ladders and were the builder's van of the period. None of them seem to give a second glance to the coalman parked up, and there is no reason why they should. He will have been a common sight in Didsbury, given that most of the houses will be heated by coal and quite a few will still use it for cooking. In 1911, *Slater's Directory* listed something like 1,200 business directly involved with delivering coal to the door.

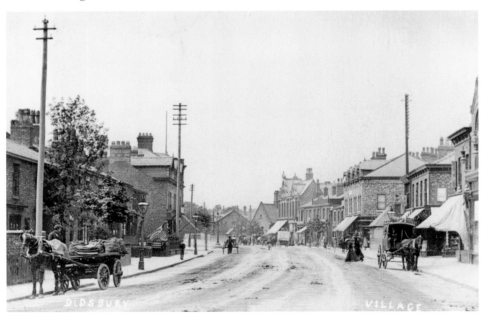

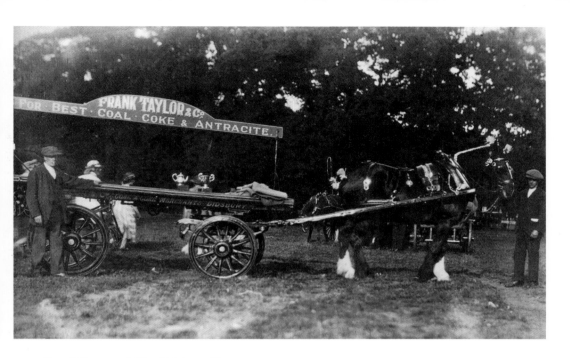

Two Winners at The Didsbury Show

We are at the Didsbury Show and these images are a reminder of just how important the horse was to how we got around. Both farmers and tradesmen were quick to spot the opportunity of parading their animals, winning a prize and gaining some advertising. Above is Frank Taylor, coal merchant of No. 13 Wilmslow Road, who, during the 1920s into the 1930s, sold coal here and won a prize. According to the message from on the back of the postcard below to Mrs Hubback of Farnham Surrey, 'Behold The President's wife giving away prizes'.

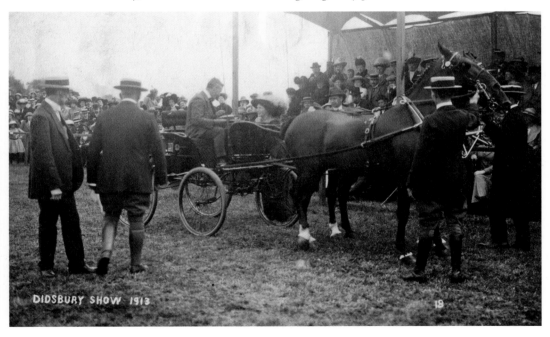

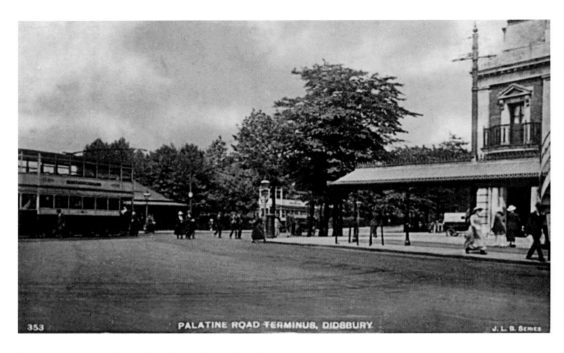

353 PALATINE ROAD TERMINUS, DIDSBURY J. L. B. Series

Palatine Road and Lapwing Lane Tram Terminus

For most of the last century this corner of Palatine Road and Lapwing Lane had been a transport hub. Just opposite the bank, where Lapwing Lane runs into Palatine Road, was the old tram terminus, which in turn was a stopping point for the bus, and behind it was the old railway station.

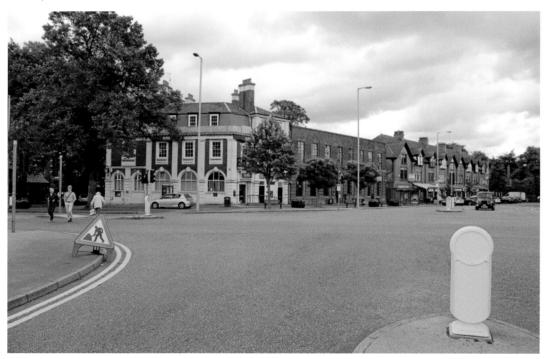

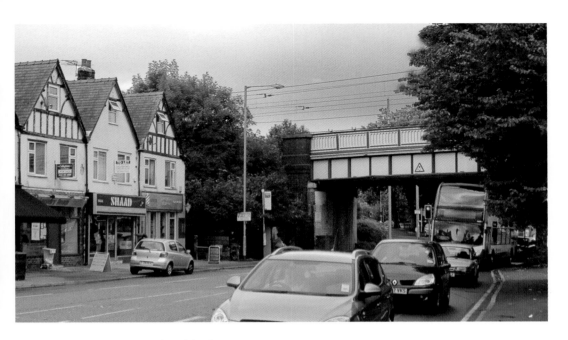

On Parrs Wood Arcade with Players Navy Cut

On a wet summer's day, the Corporation bus has just set down a group of passengers, and above them the sign announces that the East Didsbury station is still part of the London Midland & Scottish Railway (LMS). It would be another eighteen years before the LMS became part of the new nationalised British Railways. In the distance, the small, grassed park still retains its ornamental gates and, underneath, the glass and cast-iron canopy of the Parrs Wood Arcade are adverts for Players Navy Cut, Wills Golden Flake tobacco and cigarettes, Hovis Bread and the *Dispatch* newspaper.

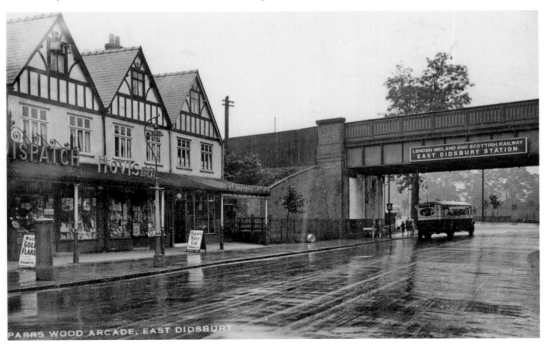

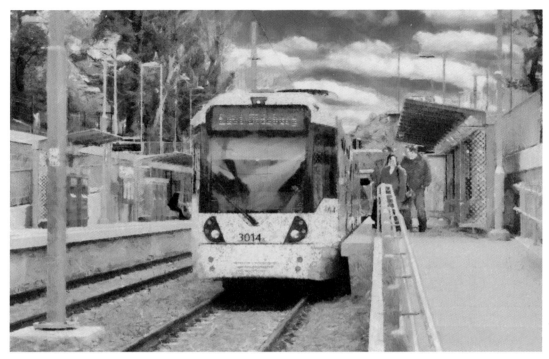

What is it About Trams That Fascinates us so Much?

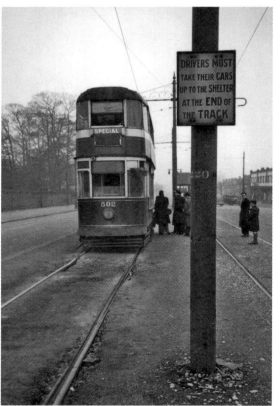

The last Manchester Corporation Tram completed its final journey on 10 January 1949. By then, there was just a few miles of track left. But in its heyday in 1928, Manchester Corporation ran 953 trams along 292 miles via 46 routes and carried 328 million passengers. Even today, there is a fascination with these sleek, slightly uncomfortable vehicles. Those on these pages were doing their business around East Didsbury from 1939 to 1947. Today, their modern equivalents have caught the imagination of a new generation of commuters.

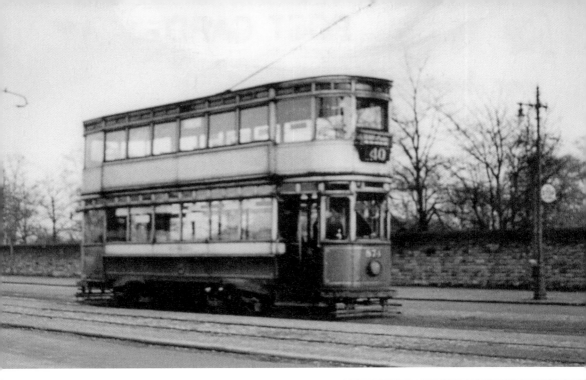

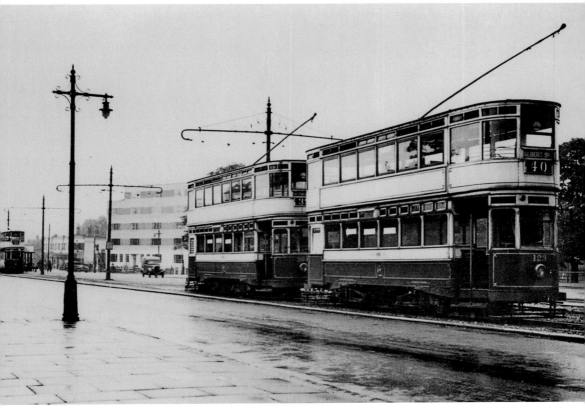

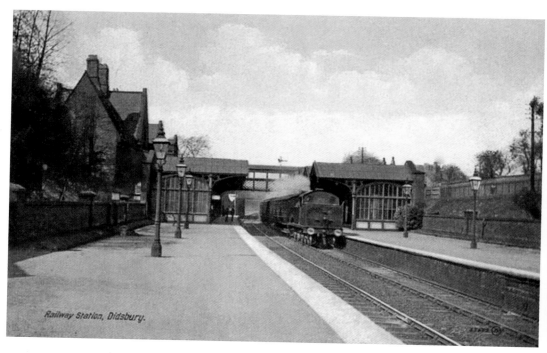

Railway Station, Didsbury.

What was Lost is Back, from Train Station to Tram Stop

Didsbury railway station was opened in 1880 and was part of the line that took you from Central station, south to Buxton and on to Derby, Sheffield and London. The station did not quite make a century of service and was closed in 1967, but just forty-six years later, the tram has come to Didsbury, with its metro stop just a little further south on School Lane.

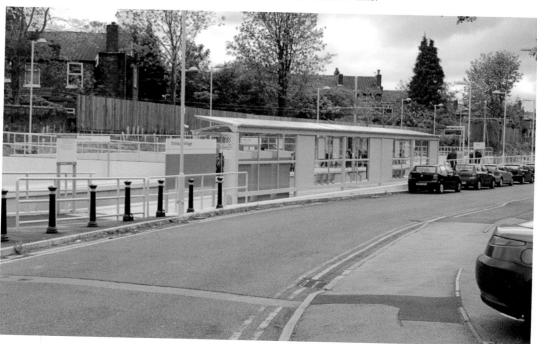

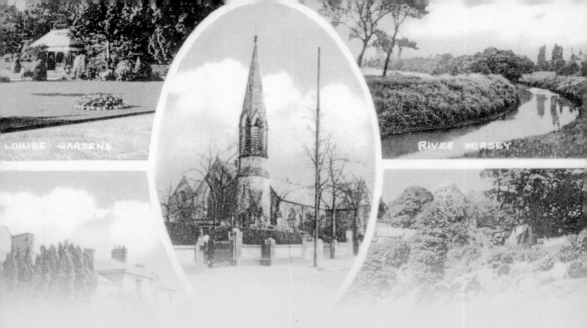

LOUISE GARDENS

RIVER MERSEY

CHAPTER 5

Postcards

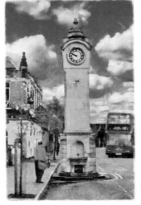

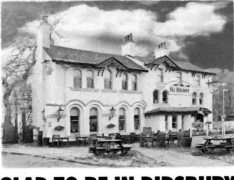

Top: The Parsonage
Above: The Library
Right: The Clock tower
Far right: The Didsbury Inn

GLAD TO BE IN DIDSBURY

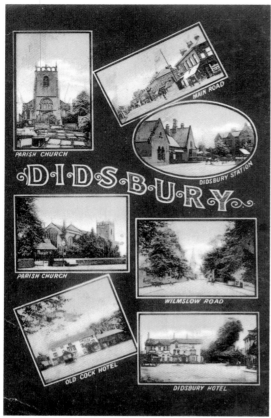

Montage Postcards, More Views for Your Money

Most postcard companies fell back on the montage card. After all, it did give you more for your money, but with quantity comes a loss of quality and detail. That said, they are a wonderful source for making quick comparisons with how Didsbury has changed over time, allowing you to wander past the parish church, along Barlow Moor Road and Wilmslow Road. Our first image was sent in 1906, and the second dates from 1955 when the Valentine Company added it to their collection. The rest span the time up to the present.

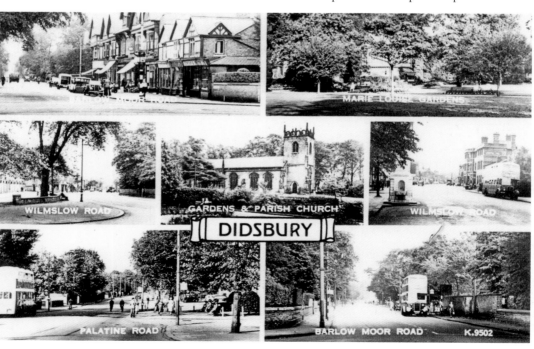

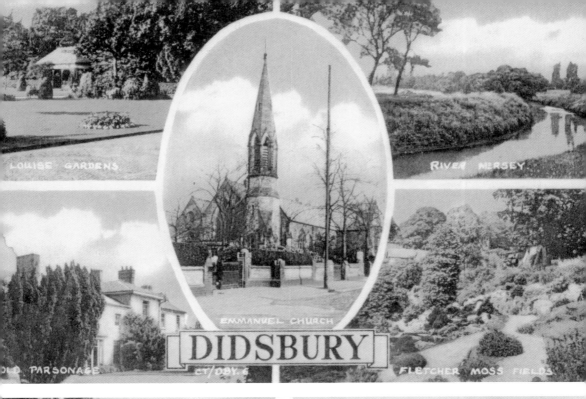

LOUISE GARDENS

RIVER MERSEY

OLD PARSONAGE

EMMANUEL CHURCH

DIDSBURY

CT/DBY. 6

FLETCHER MOSS FIELDS

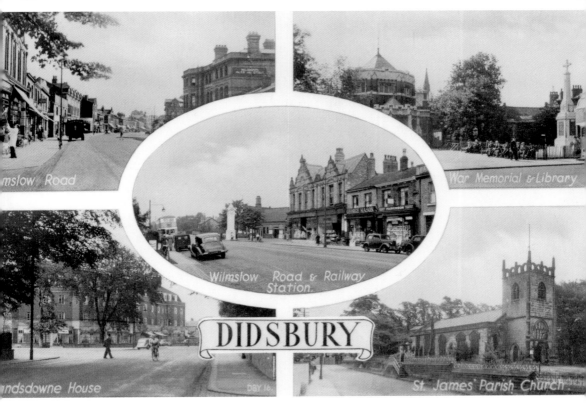

Wilmslow Road

War Memorial & Library

Lansdowne House

Wilmslow Road & Railway Station.

DIDSBURY

DBY 16.

St. James' Parish Church.

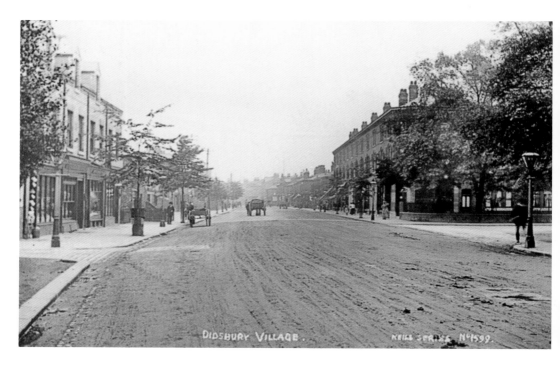

DIDSBURY VILLAGE. NEILL SERIES Nº 1599.

Hand-Coloured Prints Became Popular when Colour Printing was More Cost Effective
Just a year separates the sending of these two cards and while they are essentially the same spot, they were taken at different times. This is a fine example of colourisation or hand-colouring, which started to happen before colour photography was available. The artist would take a black-and-white photograph, which would be slightly under-exposed, and apply a series of coloured dyes. The print would then be copied and printed in quantity.

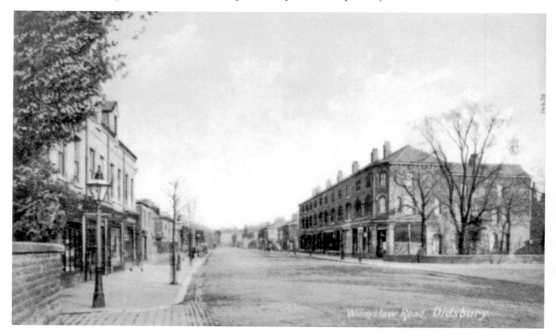

Wilmslow Road, Didsbury

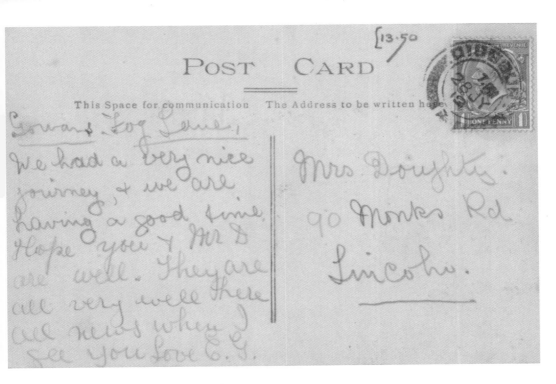

The Fastest Form of Communication

In the absence of the telephone, the picture postcard was a cheap and reliable way of keeping in touch and was used for everything from birthday wishes to holiday news. For many, it was the perfect way to remind a friend of where they were going to meet later that day.

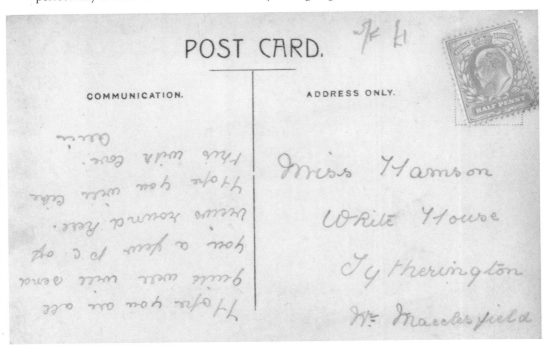

Acknowledgements

We would like to thank everyone that has helped in the research of this book, especially Paul O'Sullivan for loaning us the postcards from his extensive library and his wife Pauline for her hospitality, Steve Parle of Didsbury Civic Society and Didsbury Parsonage Trust, Mike Bath FOLLA, Digital Archives Association, www.digitalarchives.co.uk, the staff at Didsbury Library, and Sally Dervan.

Peter would also like to thank his wife Linda, son David and daughter Elizabeth for helping with the shooting of the photographs.

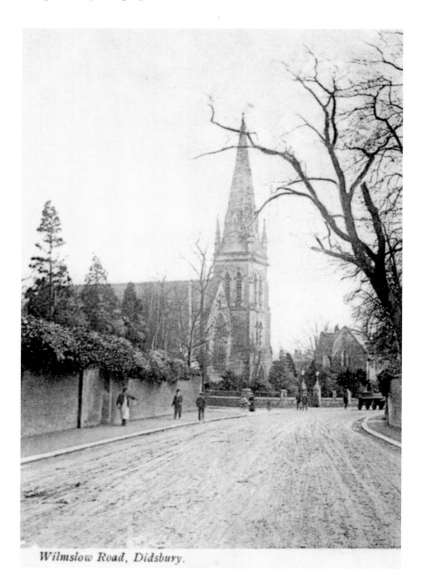

Wilmslow Road, Didsbury.